A–Z

OF

MUMBLES AND GOWER

PLACES - PEOPLE - HISTORY

Brian E. Davies

AMBERLEY

To our wonderful NHS staff and care workers

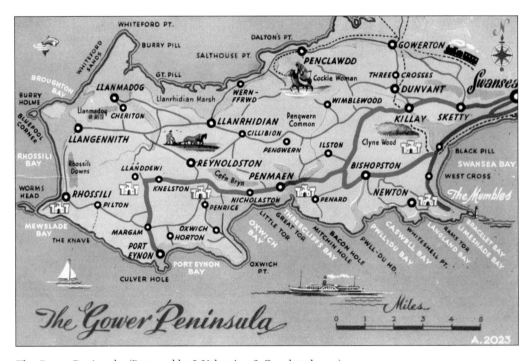

The Gower Peninsula. (Postcard by J. Valentine & Co., dated 1935)

First published 2021

Amberley Publishing
The Hill, Stroud, Gloucestershire, GL5 4EP
www.amberley-books.com

Copyright © Brian E. Davies, 2021

The right of Brian E. Davies to be identified as
the Author of this work has been asserted in
accordance with the Copyrights, Designs and
Patents Act 1988.

ISBN 978 1 4456 9880 9 (print)
ISBN 978 1 4456 9881 6 (ebook)

British Library Cataloguing in Publication Data.
A catalogue record for this book is available
from the British Library.

Typesetting by SJmagic DESIGN SERVICES,
India. Printed in Great Britain.

Contents

Introduction

On 27 January 1883, the steamship *Agnes Jack* was wrecked on the rocks of Port Eynon Point during one of the worst storms ever seen in Gower. All of her crew sadly perished, some of them after clinging onto her masts for dear life for several hours before succumbing to the raging sea. Onlookers on the shore were helpless to assist. This tragic tale is the first entry in my A to Z selection of the places, people and history of Mumbles and Gower but, happily, there are more pleasant stories to follow.

This A to Z is not a gazetteer or guide to every place in the locality, but it's a personal selection of subjects that represent the character, history and landscape of the area. The 'Mumbles Mile' inevitably makes it into the list, although I've resisted the temptation to include any individual pubs. The Pier and the 'Big Apple' are featured, as well as the Iron Mine that once traversed Mumbles Hill and the oyster fishing that helped make Mumbles famous.

There are many beautiful locations in the Gower Peninsula and I've chosen some of the best of these from Penmaen to Pwlldu and from Whiteford to Worms Head. I couldn't resist including my favourite seaside place of Langland Bay and my home village of Newton. There are prehistoric sites like Arthur's Stone and The Bulwark as well as the mysteries of Culver Hole and the 'Dollar Ship'.

I was tempted to include present-day celebrities in my collection but decided to maintain a historical theme and content myself with some notable figures from past times. These include the polar explorer Edgar Evans and sporting greats like Ivor Allchurch and the legendary schoolboy half-backs Haydn Tanner and Willie Davies who helped to defeat the mighty All Blacks in 1935. Personalities also include 'Doctor Dan' and 'Mr X' as well as the 'Queen of Reynoldston'.

I hope you enjoy my alphabetical journey!

Tor Bay and Pennard Cliffs during Gower MacMarathon Walk, 2019. (Courtesy of Phil Davies)

A

Agnes Jack

In the early hours of 27 January 1883, during one of the worst storms ever recorded in Gower, the SS *Agnes Jack* was wrecked upon the rocks of Skysea on Port Eynon Point. The three-masted, iron-hulled steamship was in passage from Sardinia to Llanelli carrying 600 tons of ore and had taken shelter in the Channel awaiting the flood tide to dock at Llanelli. At around three in the morning, she was driven onto the dangerous rocks in a powerful westerly gale and rapidly began to founder. Soon afterwards, the villagers of Port Eynon became aware of the terrible plight of the crew after hearing their cries of distress. Five of the crew had already perished after launching the ship's boat into a raging sea, where it capsized. As the towering waves lashed across the ship's decks the remaining crew took to the masts and rigging, desperately clinging on for dear life while woefully crying out for help. The Oxwich rocket crew soon arrived but their attempts to launch lines onto the vessel fell short in the howling wind. A later attempt by the Rhossili crew, made as the tide ebbed, was similarly thwarted and the helpless onlookers could only pray for the poor souls who were claimed by the sea as the foremast finally collapsed. Some had been clinging on to the masts for

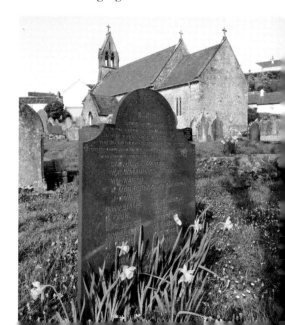

The *Agnes Jack* memorial in Port Eynon Churchyard.

around five hours. In the days and weeks that followed, the bodies of all but one of the eighteen drowned seamen were washed up on the shore and they were buried in Port Eynon Churchyard, where a memorial headstone marks their grave and records the disaster. The memorial bears the inscription: 'And the sea gave up the dead - Sacred to the memory of the eighteen mariners who perished in the wreck of the S.S. "Agnes Jack" of the Bacon Line on Port Eynon Point, Jan 27th 1883 within sight of a large number of people on the shore who were powerless to render any aid.'

There had long been a campaign for a lifeboat to be stationed at Port Eynon to protect this hazardous stretch of coast and the *Agnes Jack* disaster finally resulted in the installation of the Port Eynon lifeboat, which took place the following year. In the aftermath of the tragedy, the secretary of the new lifeboat station, Charles Bevan, wrote an epic poem of twenty-seven verses relating the story and the final six verses are reproduced here:

A mountain wave broke on the mast
Down in the surf it fell
And oh the sadness of that night
No human tongue can tell.

They battled with the raging waves
In vain the shore to reach
While scores of strong and willing men
Stood helpless on the beach.

Huge waves o'er whelmed them and they sank
So close, so near the shore
Their languid cries were hushed in death
Life's voyage now was o'er.

The gloom of death spread all around
For them there tolled no bell
The moaning of the wind and waves
Seemed like death's solemn knell.

Oh had there been a lifeboat there
To breast the stormy main
Those men might not have perished thus
Imploring help in vain.

But thus they perished – thus they sank
So very near the shore
The Agnes Jack and her brave crew
Shall plough the deep no more.

The Port Eynon lifeboat was to suffer its own tragedy on New Year's Day in 1916. Three of the crew were drowned when the lifeboat *Janet* capsized after attempting to assist the steamship *Dunvegan* off Oxwich. There is a fitting memorial to the lost lifeboatmen in Port Eynon Churchyard, adjacent to the *Agnes Jack* memorial.

There's a sad footnote to the story of the *Agnes Jack*. In 2011, the 4.5-ton anchor of the ship was recovered by divers and it was presented to Port Eynon Boat Club. It was intended to be installed as a focal point on a local roundabout, but in May 2012 thieves made off with the huge anchor, presumably intending to sell it for scrap.

Arthur's Stone

Arthur's Stone (Maen Ceti) is a remarkable megalithic chambered tomb sited high up on the north side of Cefn Bryn – the sandstone ridge that forms the spine of the Gower Peninsula. The tomb is one of Gower's best-known landmarks and dates from the end of the Neolithic period, *c.* 2500 BC. The huge capstone of the tomb is said to weigh over 25 tons and is thought to be a natural glacial boulder carried to its present location by glaciers moving south during the Ice Age. The tomb was probably formed by excavating beneath the giant stone and inserting upright supporting stones as it was dug. The two burial chambers underneath were thus created, leaving the huge capstone balanced on just a few pointed stones. A large section of the capstone, weighing around 10 tons, has broken off and is lying alongside. One story says that a local miller split this slab away in the seventeenth century, hoping to form it into a millstone, but it was too heavy to carry away. Another theory is that the capstone was struck by lightning in a violent storm, but a favourite legend is that of St David defying the Druids who worshipped around the stone. St David invoked the fire of Heaven by striking the stone with his sword, splitting it and proving it to be a pagan altar.

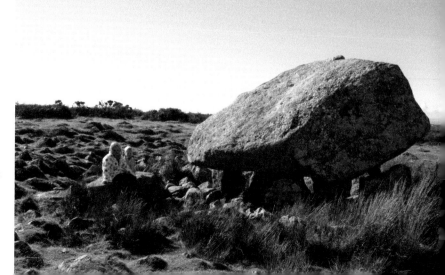

Arthur's Stone, with its great capstone, dwarfs Seren and Ieuan. (Courtesy of Phil Davies)

There are numerous other legends, one saying that the stone originated as a pebble in King Arthur's shoe that was causing him discomfort. He threw the stone from the other side of the Burry Estuary and it landed on Cefn Bryn, growing with pride at having been touched by the king. It was then raised on high by the surrounding stones. Another story says that the stone rolls down to the estuary to have a drink at midnight on certain nights of the year, such as New Year's Eve and Midsummer Eve. It is also said that a young maiden wishing to test if the young man she loved would be faithful to her should take a gift to the stone of a cake made from barley meal, milk and honey on the night of the full moon. If she then crawled around the stone three times, she would see the face of her lover if he was to remain faithful.

This protected ancient monument is located fairly near to the road from Cilibion to Reynoldston, which passes over Cefn Bryn. There is a rough parking area by the roadside from where it's a short walk to the site. There are magnificent views from Arthur's Stone, looking over north Gower and the Burry Estuary. Countless pilgrims and travellers have visited over the centuries and it is even said that some of Henry Tudor's troops made a long detour from their landing point in Pembrokeshire to pay homage at the stone before advancing to the battle at Bosworth Field.

Arthur's Stone 'sometimes wanders down to the Burry Estuary for a drink'. (Courtesy of Phil Davies)

B

Big Apple

No, not New York City but Mumbles's very own Big Apple, a much-loved landmark that has recently been granted listed building status. The Apple, located above Mumbles Pier and near Bracelet Bay, was originally built in the early 1930s to promote a cider brand called Cidatone. There were numerous similar ones in seaside towns in the UK, including at Barry Island and Porthcawl, but the one in Mumbles is thought to be the last of its kind.

For much of its life it has been a popular ice-cream kiosk, but it has also sold all manner of seaside items such as buckets and spades and refreshments and it once even offered Belgian waffles.

The Big Apple has had an eventful life, having been painted orange by pranksters in 2006 and being badly damaged when a car crashed into it in 2009. There was an online petition to rebuild it after the crash that was signed by 27,000 people, and it was subsequently repaired by the Mumbles Pier owners who reopened it the following year.

In listing the apple-shaped concrete building, the Welsh government's heritage arm, Cadw, declared it to be of 'special architectural interest as a rare and unusual

Below left: The Big Apple, Mumbles, currently closed, but now a listed building. (Courtesy of Phil Davies)

Below right: The Big Apple in earlier days.

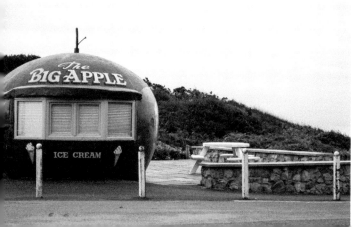
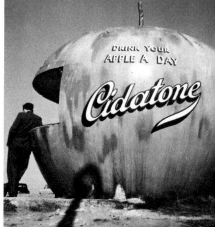

example of a seaside refreshment kiosk, important also for its historic interest being an iconic feature from the heyday of seaside entertainment and the tourist attractions of the Mumbles'.

Long may it continue to survive.

Burry Holms

Burry Holms is a small tidal island (Ynys Lanwol) at the north-west corner of the Gower Peninsula. The island has a wealth of history and prehistory, and its archaeology makes it of national importance. The island is accessible for two and a half hours either side of low tide, from the Spaniard Rocks at the northern end of Rhossili Bay. When sea levels were much lower it was an inland hill, some 12 miles from the sea, and was periodically occupied by Middle Stone Age (Mesolithic) hunter-gatherers. Evidence of this very early occupation, from around 10,000 years ago, includes discoveries of flint tools and small stone spears (microliths) among various other artefacts. Later Bronze Age occupation is confirmed by the existence of a burial cairn and midden from that period. Later still, Iron Age people created a promontory hill fort on the higher western end of the island by establishing a deep 100-metre-long ditch and bank, bisecting the island from north to south across the centre.

The medieval history of Burry Holms is evidenced by the ruined remains of a monastic settlement on the eastern side of the island, comprising a church, a hall and other outbuildings, possibly including a schoolroom. This complex probably dates from the twelfth century although there is some indication of pre-Norman development. Known as the 'Chapel of the Isle' or the 'Hermitage of St Kenydd atte Holme', the site has clear connections to the Celtic saint Cenydd, who gave his name to the nearby church and village of Llangennith.

Walking towards Burry Holms at sunset. (Courtesy of Phil Davies)

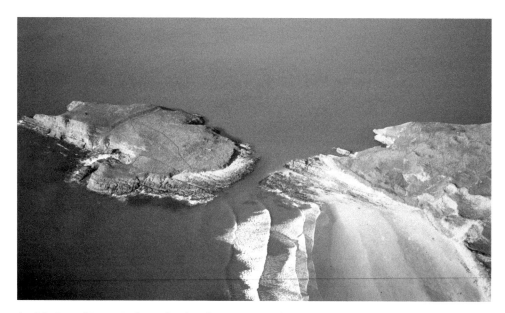

Aerial view of Burry Holms island and promontory fort. (Courtesy of Coflein)

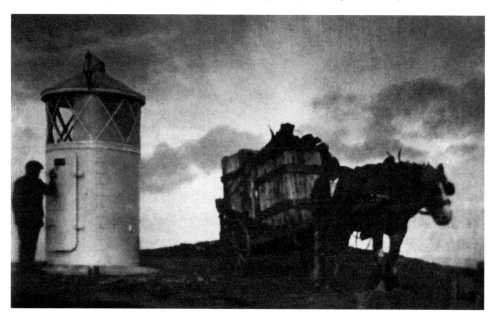

Burry Holms beacon, *c.* 1920. The horse and cart may be delivering fuel for the beacon.

Burry Holms once housed a 12-foot-high gas-lit lighthouse, established in 1920 at the time of the decommissioning of the Whiteford iron lighthouse. The Burry Holms beacon was dismantled in 1966 but the foundations remain visible.

The island has its own natural beauty due to its stunning location and has a wealth of spring and summer flowers, including thrift and sea campion.

Cockle Women of Penclawdd

The extensive cockle fisheries of the Burry Estuary have been worked for centuries, possibly since Roman times. The legendary cockle women of Penclawdd probably saw their heyday in the nineteenth and early twentieth centuries when hundreds of them would make the long daily trek out to the sands to gather the cockles. Their work was back-breaking and the women were considered among the hardiest in Wales, often working ten-hour shifts in all weathers. The work frequently involved starting off in the very early hours and the fast-moving tides and swollen channels were an ever-present danger.

The work itself involved scraping the surface of the sand and raking up huge quantities of cockles before sieving them with the riddle and washing them. The cockles were then loaded into sacks and baskets and carried on donkeys back to

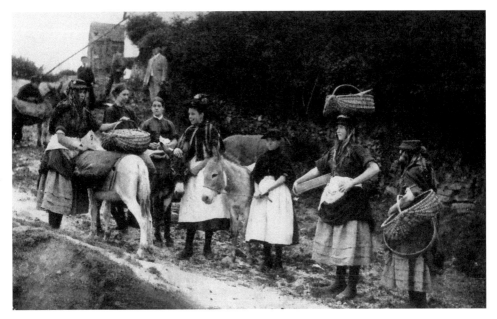

The cockle girls of Penclawdd in 1905.

Gower cockle gatherers bringing home their catch. (Courtesy of Colourmaster)

the foreshore for boiling on open fires. The cockles would be taken to the markets at Swansea and Llanelli and some were also sold from door to door across South Wales. The income earned supplemented the relatively low wages of the menfolk of Penclawdd who worked in the local collieries and industries.

In earlier times, the women would walk the 9 miles to Swansea carrying the cockles in tubs on their heads, often walking barefoot. When the railway arrived at Penclawdd, the Saturday morning train to Swansea would be thronged with cockle women in their colourful Welsh costumes on their way to market. The return train was known locally as the 'Relish Train' with the women bringing back goodies for their families, purchased with the proceeds of the cockle sales.

Ponies and carts replaced the donkeys in the 1920s and these could reach the cockle beds more quickly and carry more weight. In the late 1940s, 60 tons per week were gathered in Penclawdd and after the closure of the collieries the men of the village joined in the work, which became the main industry of the village.

The industry gradually reduced as the yields of cockles declined due to a combination of overfishing and pollution (and oystercatcher feeding), although things were better on the Llanelli side of the estuary.

Cockle gathering still continues at Penclawdd and the traditional rake and riddle are still used. Nowadays, it's mostly men that carry out the work using tractors and trailers to haul the cockles. The shellfish are processed in local factories before being distributed both locally and to Europe and worldwide.

Swansea market has a fine array of stalls selling Penclawdd cockles and laver bread (local seaweed, washed and boiled), and when cooked together with bacon these make a delicious, traditional Welsh breakfast.

Culver Hole

On the west side of Port Eynon Point, towards Overton Mere, may be found one of Gower's great mysteries. The walled-up sea cave of Culver Hole is built in a tall, narrow cleft in the cliffs and has long been the subject of speculation regarding its

history and purpose. It's certainly intriguing to find this man-made structure in such an unlikely place, accessible only from the shore at low tide. The stone-built wall is around 60 feet high with an access opening near the bottom and several windows at different heights. There's a series of staircases inside, suggesting there may have once been floors at various levels. A clue to its one-time use is found in the name *culver*, which is an old word for pigeon or dove and the structure was probably used as a dovecot or columbarium in medieval times, providing meat and eggs all year round, probably for the gentry. There are around thirty tiers of nesting boxes inside giving strength to the theory, although this may have been a secondary use considering the cave's inaccessibility. There are suggestions that it may once have been a defensive stronghold or storage facility for the lost Port Eynon Castle, referenced in the fourteenth century and whose location may have been on the point, up above the cave. There have also been archaeological finds in the cave suggesting very early occupation. Culver Hole is now classified as a Scheduled Ancient Monument.

Legends of smuggling abound, of course, and there's little doubt that Culver Hole would have been a perfect place to store contraband. There are reputed associations with the Salthouse on the other side of the point – one-time abode of John Lucas, the renowned local pirate. There's even a story that there was a secret tunnel between the cave and the Salthouse, some 400 yards away. This may be a bit fanciful as it would probably have been possible to carry the brandy casks the short distance across the narrow point under cover of darkness.

There's another cave called Culver Hole near Llangennith that is semi-tidal and from which early human remains have been recovered.

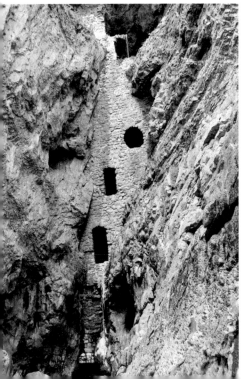

The mysterious Culver Hole at Port Eynon Point. (Courtesy of Dave Morgan)

D

Daniel Jones

Daniel Jenkyn Jones OBE (1912–93) was one of Wales's most important classical composers of the twentieth century, particularly in the post-war years. Perhaps best known for his string quartets, symphonies and song settings, his body of work also encompasses many other spheres and his music is both contemporary and accessible.

Dan lived in Newton village for much of his later life but was born in Pembroke and spent his early years in Swansea. He loved literature and was a boyhood friend of Dylan Thomas, featuring in Dylan's *Portrait of the Artist as a Young Dog* in a short story called *The Fight*, about their schoolboy squabble. Their close friendship endured until Dylan's death in 1953. The following year, Dan composed the song settings for the first radio broadcast of *Under Milkwood*. He also edited a collection of Dylan's poetry in 1972 and his memoir *My Friend Dylan Thomas* was published in 1977.

Back in the early 1930s Dan was a member of the famous Kardomah Gang, a group of artists that met in a Swansea café and included Dylan, the painter Alfred Janes and the poet Vernon Watkins. Another member of the gang, Charles Fisher, thought Dan a genius and was to say later 'he deserves to be regarded as Dylan's equal in the field of

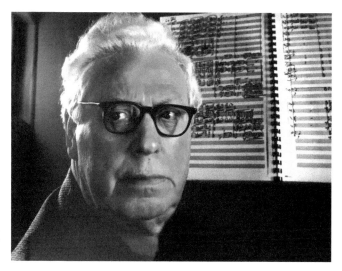

The composer Daniel Jones with his music. (Courtesy of Graham Matthews)

creation'. Dan studied English Literature at Swansea University, where he gained an MA, and in 1935 he entered the Royal Academy of Music in London where his teachers included Sir Henry Wood. He won the Mendelssohn Scholarship in the same year, enabling him to study in several countries including Czechoslovakia, Germany and the Netherlands. This helped him to develop his formidable language skills, which were put to good use during the Second World War when he became a captain in the Intelligence Corps, working at Bletchley Park as a cryptographer and decoder.

After the war he won the first prize of the Royal Philharmonic Society for his *Symphonic Prologue* and thereafter many of his compositions were commissions, including those for the Festival of Britain, the BBC, the Swansea Festival and the Royal National Eisteddfod.

He was twice married, fathering four daughters and a son (inevitably named Dylan after his great friend). Daniel Jones passed away in Newton in 1993 at the age of eighty.

My own memory of 'Doctor Dan' comes from seeing him in the Newton Inn, often with his wife Irene, where they were regular visitors. I was privileged to enjoy chats with him about music and, of course, Dylan Thomas, and he was once kind enough to pose for a photograph with an American friend of mine who was very keen to meet him. Much more recently, it was a joy to be present at a performance of his cantata *The Country Beyond the Stars* (a setting of verses by Henry Vaughan) performed by the BBC National Orchestra and Chorus of Wales at a St David's Day celebration in Cardiff.

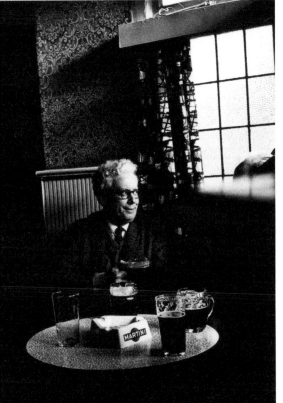

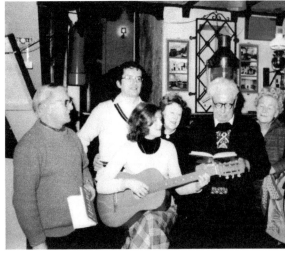

Above: Daniel Jones performing with the Dylan Thomas Society at the Antelope Inn, *c.* 1977.

Left: 'Doctor Dan' relaxing at the Newton Inn in 1966. (Courtesy of Bernard Mitchell)

D

Dollar Ship

Rhossili Bay is known for its magnificent, sweeping 3-mile beach, although in past times it has seen more than its share of shipwrecks. Many a vessel has been driven onto the sands here and broken asunder by wild winter storms and pounding Atlantic breakers. Rhossili has also had a reputation for smuggling and wrecking and some unfortunate wrecks may have been lured ashore by the swinging of a lantern rather than extremes of the weather. The wrecks of the barque *Helvetia* and the paddle steamer *City of Bristol* are well known, but perhaps the most famous of all is that of the mysterious 'Dollar Ship'.

In the year of 1807 the *Cambrian* newspaper reported that during an exceptionally low tide a haul of Spanish silver dollars was found on a wreck at the sea's edge and around 12 pounds of coins were recovered. The coins were Peru dollars and half dollars and were dated 1625. They bore the arms of Philip IV and were minted at Potosi, the Spanish colonial mint in Bolivia. The wreck was thought to be that of the rich Spanish vessel *Scanderoon Galley*, wrecked in the late seventeenth century and which may have been carrying the dowry for a Spanish princess who was due to wed an English nobleman. Legend says that the roguish Mansel of Henllys made off with the bulk of the haul, against the rule of the lord of the manor, and fled the country soon afterwards, never to be seen again.

The story moves on to 1833, when four beachcombers noticed an unusual shift in the sands at a very low tide. They found more of the treasure, but as they were desperately digging the tide rapidly came in, frustrating their efforts. They left a buoy and line ashore to mark the spot, but this mysteriously disappeared overnight. The word quickly got around and the beach was besieged the next day by locals feverishly looking for the silver. Many were successful and, as well as the dollars, two iron cannons were found, some leaden bullets and a part of a navigational instrument. Some of the coins found their way to Swansea, where they were probably sold and melted down. Other finders built houses with their newly gained wealth; a house called Dollars Cottage still exists near Llangennith.

The searches have continued for generations at very low tides and many locals are still convinced that vast quantities of dollars remain buried in the sands. Modern-day treasure hunters with metal detectors had better beware, however, as the spirit of Mansel of Henllys still haunts the beach in the 'Spectral Chariot of Rhossili Sands' – a black coach drawn by four grey horses.

The story of the Spanish 'Dollar Ship' should not be confused with the finds of gold moidores and doubloons at nearby Bluepool Corner. These Portuguese coins were discovered in 1797 by John Richards and his wife Honora while drawing for fish with nets. In 1840 and 1857 more gold coins were found at the location – further evidence of the treasure to be found around Gower's golden coast.

Edgar Evans

Edgar Evans of Gower, who tragically perished with Captain Scott on the ill-fated *Terra Nova* expedition to the South Pole in 1912, was born in Middleton near Rhossili in 1876. The son of a seaman, he moved to Swansea as a young boy and joined the Royal Navy at the age of fifteen. He served with Scott on the battleship HMS *Majestic* in 1899 and clearly impressed him with his strength and resourcefulness. He volunteered to accompany Scott on his *Discovery* expeditions to Antarctica between 1901 and 1904 before returning to Gower to marry his cousin, Lois Beynon, whose parents kept the old Ship Inn in Middleton. Evans helped out in the pub and his tremendous strength was clearly an asset. He once expelled a group of Swansea troublemakers from the Ship, taking them outside two at a time. They didn't come back!

Scott admired Petty Officer Evans for his practical skills and selected him for the British Antarctic Expedition that left Cardiff in the *Terra Nova* on 15 June 1910 to

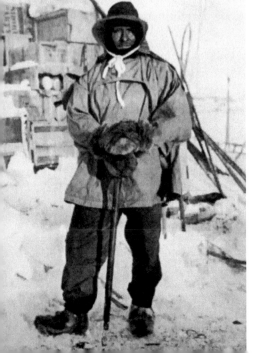

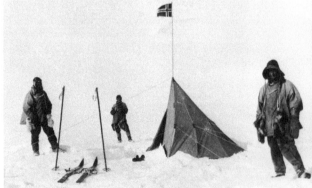

Above: Captain Scott, Edward Wilson and Edgar Evans at Amundsen's tent at the South Pole, 18 January 1912. (Courtesy of Canterbury Museum, NZ, ref. 19XX.2.639)

Left: Edgar Evans in Antarctica, Ross Dependency. (Courtesy of Scott Polar Research Institute)

the cheers of vast crowds. After sailing across the world to New Zealand and on to Antarctica, and setting up base camp, Scott and his companions finally reached the South Pole on 17 January 1912. The polar party of Scott, Evans, Henry Bowers, Lawrence Oates and Edward Wilson had man-hauled their sledges for eleven weeks from base camp across the most inhospitable terrain on earth to reach the Pole only to find that Amundsen had beaten them to it by just a month. One can only imagine their despair when they found the Norwegian flag flying at the South Pole.

They faced an awful return journey of 800 miles in terrible conditions and Evans, who had earlier suffered a badly cut hand, was also suffering from frostbite. He then sustained a serious head injury after falling into a crevasse and collapsed on 16 February, dying the following day without regaining consciousness. His companions were also to perish later, but Evans's sad demise had been recorded in Scott's diary. A relief party later found three bodies, but not those of Oates or Evans, who still rest somewhere near the Beardmore Glacier in Antarctica, one of the southernmost places on Earth. Evans's widow, Lois, erected a plaque in his memory at St Mary's Church in Rhossili, where they had been married in 1904. The plaque bears Tennyson's words: 'To seek, to strive, to find and not to yield.'

Robert Falcon Scott and his companions lost their lives but created one of the great legends of human endeavour. The classic 1948 film *Scott of the Antarctic* told their story, with John Mills playing Scott and James Robertson Justice playing Edgar Evans.

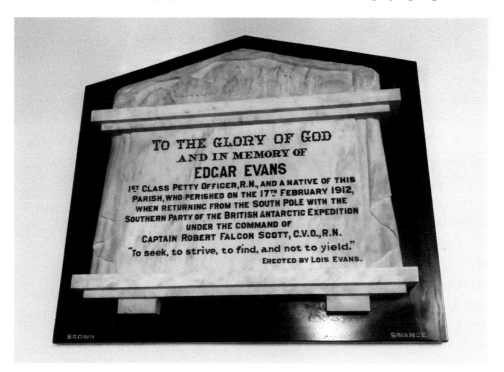

The plaque in memory of Edgar Evans at St Mary's Church, Rhossili.

Fairwood Common Aerodrome

RAF Fairwood Common became operational on 15 June 1941, during the Second World War, having been established over the previous twelve months on common land in Gower. The aerodrome was planned as a day/night fighter station to protect the south and west of Wales and shipping in the Bristol Channel, as well as defending the south-west of England. The first squadrons to be based there were Hurricanes and Beaufighters, and later Spitfires and Lysanders. Many missions were flown during the war, including fighter support for bombing attacks on Le Havre and Brest and the defence of Plymouth and Bath during enemy raids. The station fulfilled a variety of other military roles and numerous enemy aircraft were destroyed in successful sorties flown from Fairwood. There were also a number of losses and crashes and the aerodrome itself was attacked several times. The memorials of RAF personnel killed while based at Fairwood may be found at St Hilary's Churchyard in Killay.

At the end of the war the station became a training and maintenance centre, serving as a base for armament practice on the Whiteford Burrows firing range in the west of Gower. The station was decommissioned by the RAF in 1949 and became the home of Swansea Flying Club, which hosted numerous air shows, air races and motor sports in the early 1950s. The county borough of Swansea took over in 1957 and Fairwood

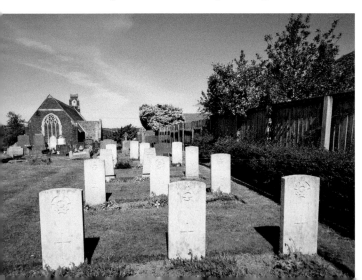

Memorials at St Hilary's Church, Killay, of RAF personnel killed while based at Fairwood during the war.

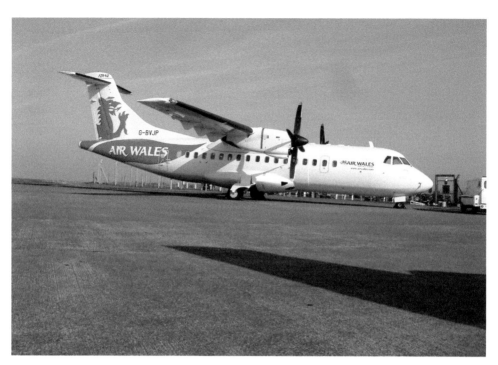

Air Wales operated from Swansea Airport in the early 2000s.

was renamed Swansea Airport, officially opened by Group Captain Douglas Bader CBE on 1 June 1957.

Cambrian Airways took over the commercial operations, with flights to various destinations, but the airport was not financially viable and regular flights ceased in 1969. There were numerous ad hoc and charter flights in the 1970s and '80s before the lease was bought by successive private entrepreneurs. In the early 2000s, Air Wales ran commercial flights to Dublin, Cork, Amsterdam, Jersey and London, although the airport still couldn't pay. The Wales Air Ambulance helicopter service operated from the airport for a period but has since been relocated to Llanelli. Fairwood also hosted the Gower Show between 1987 and 2001.

Redevelopment of the airport has been proposed but this would require substantial investment, including financial support from public funds and there has been widespread local opposition due to the impact on the environment. Fairwood Common is a conservation area within the Gower Area of Outstanding Natural Beauty and a local coalition group called SANE (Swansea Airport No Expansion) has strongly opposed extra flights from the airport.

Swansea Airport continues to operate, however, and is nowadays mainly used for light helicopters and privately owned small aircraft as well as corporate, police and military helicopters. Current facilities include gift flights, refuelling and flying schools and there have been aerobatic activities and parachute jumps in recent times (my daughter, Lucy, did a parachute jump for charity from Fairwood a number of years ago).

Fairyhill

The five-star hotel and wedding venue at Fairyhill in Reynoldston has a long and distinguished history. This Grade II listed mansion, set in 24 acres, was probably built around 1700 and was originally called 'Feryhill'. It became known as 'Peartree' during its early days and members of the prominent Lucas family lived there in the eighteenth century. When John Lucas and his young bride moved there in 1777 they decided to change the name back to 'Fairyhill', and the magical name has endured ever since.

In 1813, the house was let to Lady Barham, a strongly religious lady whose father was First Lord of the Admiralty at the time of Trafalgar. She decided to leave London society behind at the age of fifty-one to move to Gower and attend to the 'spiritual darkness' of the area. She built no less than six Nonconformist chapels in Gower as well as carrying out many charitable good works. She herself attended Bethesda Chapel in Burry Green and was carried there from Fairyhill across the fields by sedan chair. She had her own reserved pew at the chapel and also had a private room behind the pulpit to which she could repair if she found the sermon too boring.

After Lady Barham died in 1823 another member of the Lucas family lived at Fairyhill, but the house soon had to be sold to pay off his racing debts. The next occupant was Revd Samuel Phillips, a man of the Established Church who was twice married – the second time, improbably, to one of Lady Barham's daughters. He was an extremely extravagant and intemperate individual who frittered away the dowries of both his wives, and on his death in 1858 he was said to have owed his servants ten years of wages. The house again had to be sold, but this opened a new chapter in the Fairyhill story.

The house was bought by Starling Benson, the prominent Swansea coal owner, philanthropist and one-time mayor of Swansea who was also chairman of the Harbour Trust. He was to share his home at Fairyhill with his half-brother, General Henry Benson, a distinguished veteran of the Crimean War and the Indian Mutiny. When Starling Benson died in 1879 after suffering a fall in a quarry while out shooting, the house was left to General Benson whose large family continued in occupation. General Benson's wife was Mary Henrietta Wightman, a sister-in-law of the celebrated Victorian poet and critic Matthew Arnold. After a visit to Fairyhill in 1879 Arnold wrote, 'We had very much enjoyed Fairy Hill; that peninsula of Gower was something so new and remote, the coast is so beautiful, the flowers and ferns so interesting.'

The Benson family, with their nine children, continued with benevolent good works in the locality, much in the manner of Lady Barham, contributing to the church and the educational needs of the area and providing valued support to the farming community. They also carried out many improvements to Fairyhill, including an additional wing, a boating lake and some fine landscaping.

After the last of the Benson family left in 1921, Fairyhill enjoyed mixed fortunes under several owners and eventually fell into a sad state of disrepair. In 1982, however,

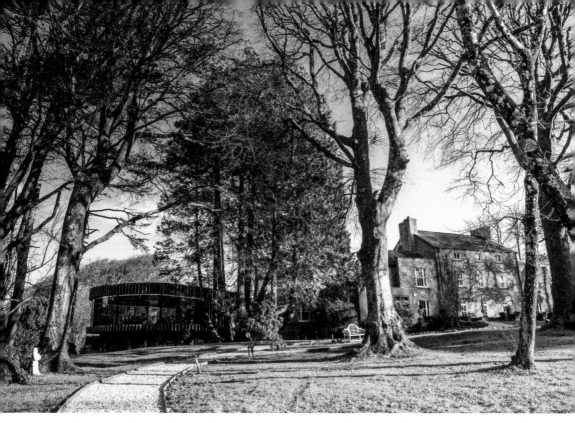

Fairyhill grounds with the modern extension alongside the original mansion. (Courtesy of Marc Smith Photography)

the house was acquired by Mr and Mrs Frayne, who converted the house to a hotel and restored it to its former elegance. It has been a high-class country house hotel and restaurant since then and recently became an exclusive wedding venue – a sister to a similar venue in Oldwalls, Gower. With a stylish, modern extension and beautiful grounds, the Fairyhill mansion continues to provide a very special location in keeping with its illustrious history.

Graves End

Examination of the Ordnance Survey map of south Gower reveals a location called Graves End at the south-east corner of Pwlldu Head. This name evokes memories of one of the greatest maritime disasters to befall this rocky section of coast, a terrible tale of press gangs and shipwreck.

The story begins on the sands at Blackpill one day in 1760, when John Voss of Nicholaston and his friend, John Smith, were making their way home on horseback from Swansea. They were approached by a press gang of around a dozen sailors led by a lieutenant who attempted to apprehend them for naval service. The two Gower

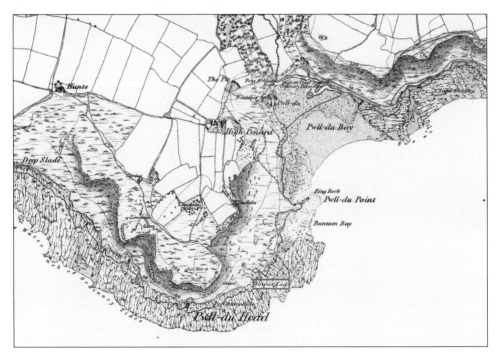

Map of 1883 showing the location of Graves End on Pwlldu Head. (Reproduced with the permission of the National Library of Scotland)

men resisted, having dismounted, and stood back to back to fight them off, laying out several sailors, before the lieutenant struck Mr Voss a savage blow with his cutlass, 'almost severing his arm at the shoulder'. They continued to fight on, however, until help arrived and the press gang was eventually seen off. Fortunately, Mr Voss was able to recover from his injuries. The press gang was from the Admiralty tender *Caesar*, which lay in the Mumbles Roads.

On 28 November 1760, the *Caesar* and her companion tender *Reeve* sailed on the ebbing tide, with their human cargo of pressed men, bound for Plymouth. Out in the hazardous waters of the Bristol Channel they were faced with deteriorating weather and a turning, fast-flowing tide, so both vessels decided to turn back for the shelter of Mumbles Head. The *Reeve* made it to safety but in the poor visibility and darkness the *Caesar* mistook the headland of Pwlldu for that of Mumbles Head. She was driven onto the rocks of Pwlldu Head where she became stuck fast in a deep cleft, at the mercy of the rising tide and the breakers crashing in. Some survivors were able to clamber over the bowsprit onto the rocks to safety and to make contact with the local community of High Pennard at the top of the cliff. These were mainly crew members including the *Caesar's* master and mate. Those trapped below decks were not so fortunate. They included a large number of press-ganged men who were battened down securely, with some reports even suggesting they were manacled. They had no chance whatsoever and most were drowned in the hold by the rising tide.

The next morning the villagers were horrified to find many bodies washed ashore after the ship had broken up, together with the detritus of the wreck, including various items of ordnance such as muskets, pistols and swords. The number that perished was officially recorded as sixty-five, although a figure nearer 100 was reported locally. One of the witnesses at the scene was none other than John Voss, who is said to have identified the body of the lieutenant who attacked him with his cutlass. Poetic justice indeed. Over the following days the bodies were buried in a mass grave at the closest available place, a melancholy spot known ever since as Graves End. The grave site is marked by a rough circle of stones and the deep cleft between the rocks is still called Caesar's Hole.

Green Cwm

Green Cwm is a lovely grassy valley set within woods and limestone outcrops just to the north-west of the village of Parkmill. The small car park at Green Cwm may be reached by following the lane from Parkmill towards Parc-le-Breos for around half a mile, and from the car park a walk along the valley is rewarded with a number of fascinating sights.

A short distance along, on the left side, is the impressive Giant's Grave, more properly known as Parc Cwm Long Cairn or Parc-le-Breos Burial Chamber. This Neolithic chambered tomb, used for the communal burial of the dead, dates from

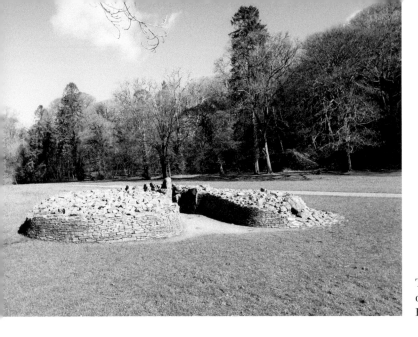

The Giant's Grave
or Parc-le-Breos
Burial Chamber.

around 3800 BC and has been carefully preserved. The 72-foot-long cairn consists of a bell-shaped forecourt, a central passageway lined with limestone slabs and two pairs of stone chambers where human remains were once placed. The whole site was originally covered over with earth but excavations at the site have discovered the bone fragments of around forty individuals together with shards of Neolithic pottery. The cairn is maintained by Cadw, the Welsh government's historic environment service.

On the opposite side of the track is a beautifully preserved limekiln, one of many in Gower, illustrating the important part that limestone quarrying and lime burning once played in the area. The lime produced from these kilns was particularly important for use as a fertiliser, for agriculture both locally and further afield.

A further 150 yards along the Cwm there's a path on the right side leading up to Cathole Cave, a deep triangular fissure in the limestone cliff, around 50 feet above the valley floor. The cave has two entrances and excavations here have revealed evidence

The well-preserved
limekiln in Green
Cwm.

of human occupation, possibly going back as far as 26000 BC. Flint blades used by hunter-gatherers have been found here among signs of Mesolithic and Bronze age occupation. Animal remains here have included brown bear, mammoth and woolly rhinoceros. Rock art was discovered at the rear of the cave in 2010 and this has been dated to around 14,000 years ago. It is thought to be the earliest example of cave art anywhere in the British Isles.

The whole area of Green Cwm was once part of a medieval deer park used for hunting, and the woodland on the west side of the Cwm is a beautiful place to walk, particularly in springtime with its sweeping carpets of bluebells and wild garlic.

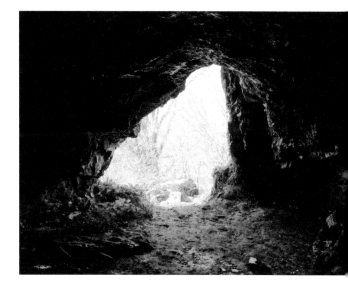

Right: The interior of Cathole Cave.

Below: The woods near Green Cwm in Springtime.

Haydn Tanner and Willie Davies

The north Gower village of Penclawdd is well known for its rugby and the most celebrated players in its history are undoubtedly the legendary Haydn Tanner and Willie Davies, the half-back pairing that starred together for Swansea and Wales. The two cousins were schoolboys at Gowerton County School when they played for Swansea in the epic 11-3 victory over the 'unbeatable' New Zealand All Blacks in 1935, and Swansea became the first club team in history to defeat the southern hemisphere 'big three' – Australia, South Africa and New Zealand. After the match, the All Blacks skipper, Jack Manchester, pleaded with the media reporting to the New Zealand public:

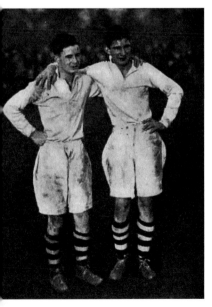

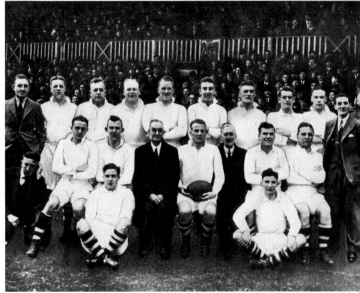

Above left: The 'schoolboy' half-backs for Swansea vs Blackheath, 3 November 1934. (Courtesy of Swansea RFC)

Above right: The Swansea team that defeated the All Blacks in 1935, with Willie Davies and Haydn Tanner seated in the front row. (Courtesy of Swansea RFC)

'Tell them we were beaten but don't tell them we were beaten by a pair of schoolboys.' The previous season the two had played for their village team, when Penclawdd RFC had its headquarters at the Ship and Castle pub, where Willie Davies's father was the landlord. They were to go on to much greater things.

Haydn Tanner, the scrum-half, was born in Penclawdd in 1917 and played with Willie for the Welsh Secondary Schools. After their outstanding performance in Swansea's victory against the All Blacks, Haydn Tanner was selected for his first cap for Wales, also against the All Blacks, in the same year. He again emerged victorious in Wales's famous 13-12 victory. He went on to win twenty-five caps for Wales, twelve of them as captain, and would have won many more were it not for the interruption of the Second World War. He was never dropped for Wales, and still holds the record for the longest unbroken series of caps in history – the fifteen-year period from 1935 to 1949. He toured South Africa with the British and Irish Lions in 1938, appearing in the second Test against the Springboks. He also captained the Barbarians against Australia in 1948, a fixture that became an end-of-tour tradition.

Haydn Tanner studied chemistry and maths at Swansea University and served in the Royal Corps of Signals during the war. He later took a teaching job in Bristol before becoming an industrial chemist in Surrey, where he coached Esher and joined London Welsh. He died in his sleep in 2009, aged ninety-two. He was undoubtedly one of the greatest scrum-halves ever and his great contemporary Bleddyn Williams said of him: 'Among all the scrum-halves I've seen and played with, he would reign supreme.'

Willie Davies, the outside-half, was also born in Penclawdd, in 1916, and took a different path from his cousin, becoming a dual-code rugby international after 'going north'. In rugby union, Davies was first capped for Wales in 1936, against Ireland, when Wales won the Championship. He vied for his place in the Welsh team at the time with another great fly-half, Cliff Jones, and the last of his eight Wales caps was also against Ireland, in 1939, when he scored all of Wales's 7 points, including the last ever 4-point drop goal in the Five Nations. He played club rugby union for Swansea and Headingley before signing as a professional for Bradford Northern rugby league club in 1939.

He served in the RAF during the war before returning to become a superstar of the rugby league game, playing in a great Bradford Northern team. He played rugby

Haydn Tanner in action for Swansea v. Newport, 28 September 1946. (Courtesy of Swansea RFC)

league for Wales and Great Britain, touring Australia and New Zealand in 1946. He also appeared in three successive Rugby League Challenge Cup Finals at Wembley – in 1947, 1948 and 1949 – winning the Cup on two of those occasions. He won the Lance Todd Trophy as the outstanding player of the 1947 final, the first Welshman to achieve the honour. He finally hung up his boots in 1950. In his personal life, Willie Davies taught in Leeds and Bingley before spending most of his career teaching in Weston-super-Mare. He passed away in 2002, aged eighty-six. In the words of his cousin, Haydn Tanner, 'Willie was the outstanding example of an athlete with perfect rhythm, it was a joy to watch him run through the opposition without any apparent effort.'

Tanner and Davies from Penclawdd were truly two of the greats of Welsh rugby.

Horse's Head

The Mumbles Horse's Head dates from the 1870s but the origins of the *Mari Lwyd* (Grey Mare) go back much further. This is a Christmas or New Year tradition that has been carried on for centuries in the Welsh valleys and in parts of England (where it's called Hodening).

The Mumbles Horse was originally called Sharper, and he once pulled a cart that delivered vegetables in the locality. He was always made a fuss of by Mumbles folk and there was sadness when he became ill and died in 1873. He was buried in a field near Barland in Bishopston, but soon afterwards it was decided to use Sharper's head for the Christmas custom in Mumbles. He was reburied at Limeslade in lime soil, which cleaned the bones of the skull, which was then dug up each Christmastime. The jaws were wired so that they could be opened and closed and the head was decorated with ribbons and rosettes, with glass bottle bottoms for eyes and strings for a mane. The head was then placed on a broom handle to hold it upright with a sheet placed over it so that a man could go underneath, astride the pole. He was thus able to act the part of the horse, moving around and opening and closing the jaws to great effect. A group would take the horse around the village for the two weeks before Christmas, going in procession through the streets and visiting the pubs and big houses. Special songs were sung, including 'Poor Old Horse' and 'Mistletoe Bough', and people would feed the horse with fruit and mince pies. The man leading the horse, known as the 'horseler', wore a top hat and tails and collected money for charity in his top hat.

The Mumbles Horse's Head was originally started by William Jenkins. The Jenkins family and their friends and more recently the Bowden family, have continued the tradition over many years. The poor old horse was given a break during the two world wars but was regularly active up to the 1970s and '80s, and has made an appearance on numerous occasions since then. I well remember a Christmas event at the Newton Inn in 2003, when a group of singers from the Morriston Orpheus Choir was joined by the Horse's Head. The 'Poor Old Horse' song was well-sung that evening!

Above: The Mumbles Horse's Head at the Newton Inn, Christmas 2003.

Below: The picture here shows the Horse's Head with the Sweyn's Ey Mummers, who were performing the 'Christmas Play' in Mumbles in December 2003. The performers are, left to right: Andy Baker (Hungry Hound), Keith Lascelles (The Doctor), Ken Simpson (Old Father Christmas), the Horse's Head, Ken Bond (Nid Noddy), Paul Tarrant (King George) and Jonathan Baker (Turkish Knight).

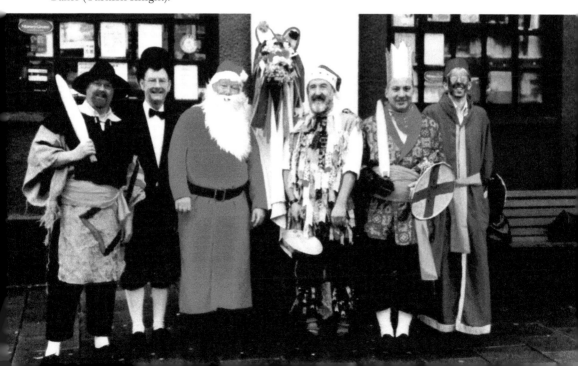

Iron Mine, Mumbles Hill

Iron ore was mined on Mumbles Hill from 1845 until the end of the nineteenth century, although deposits may have been discovered and exploited by the Romans nearly 2,000 years earlier. The vein of hematite ore was mined by opencast methods and a long deep trench was excavated from just beyond the present Verdi's restaurant, right across the hill to Limeslade Bay. The ore mined on the hill was broken up and carried down to the beach then loaded onto small ships for transportation to iron works in Swansea and Briton Ferry.

The 'coast to coast' trench became known as 'The Cut' and was still open until the 1930s, when the Mumbles sewage treatment scheme was carried out and the cut was

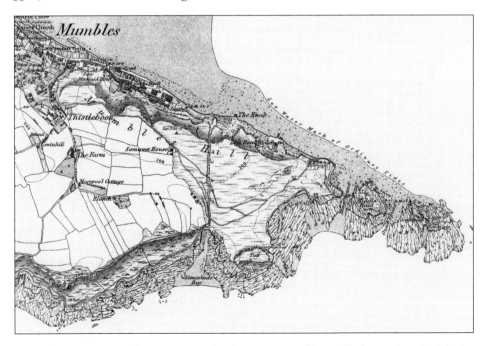

Map of 1883 showing the Iron Mine 'Cut' across Mumbles Hill. (Reproduced with the permission of the National Library of Scotland)

filled with rubble. Traces of the trench can still be seen from the road and on the top of the hill.

An early owner of the iron mine was David Pugh, landlord of the Ship Aground pub at the bottom of the cliff. He decided to build another pub at the top of Mumbles Hill in 1849, named the Somerset House, which no doubt provided refreshment for the thirsty miners and visitors to the hill. Pugh was censured by the coroner in 1852 at an inquest at the Ship and Castle Hotel into the death of Timothy O'Connor who was killed at the Iron Mine by rocks falling from a bucket.

The well-known Libby family managed the iron mine in the 1850s and ran their forge behind the Ship & Castle Hotel, later moving to a site next to the Bristol Channel Yacht Club. The Somerset House didn't last for many years as a pub but the house itself has been much improved and extended over the years and enjoys brilliant sea views.

Ivor Allchurch

Ivor Allchurch MBE will always be remembered as the 'Golden Boy of Welsh football'. He was born in Swansea and also lived for much of his life in Plasmarl, Mumbles and Bishopston. During his illustrious professional football career, he played for Swansea Town, Newcastle United and Cardiff City and also a number of non-league clubs in his later playing days. He won sixty-eight international caps for Wales, scoring twenty-three goals – a record at the time. He was a classical, elegant inside forward, one of the great Swansea footballers of the period that included John and Mel Charles, Terry Medwin, Cliff Jones and, of course, Ivor's brother Len. Off the field, Ivor was quietly spoken, modest and unassuming.

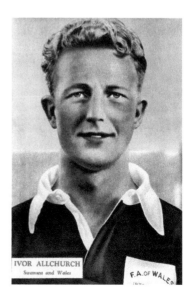

Ivor Allchurch of Swansea and Wales.

He was born in Waunwen in Swansea in 1929, one of eight children, and at the age of fourteen was spotted playing local youth football by a Swansea Town scout, who persuaded him to join the club. After his national service in the army he rejoined the ground staff at the Vetch Field and ended up playing over 400 games for the Swans in two spells, captaining them and scoring nearly 200 goals. He was a home town boy and was loyal to Swansea for all of his early career, despite attracting the serious attention of numerous top-level clubs. Eventually, at the age of twenty-eight, he was sold to Newcastle United for £28,000 – a huge fee at the time. He was to spend four seasons on Tyneside, making over 150 appearances and scoring over fifty goals. He returned to Wales in 1962 to play for Cardiff City, where he spent three successful seasons and was described in the local press as 'one of the best skippers the club has ever had'. At the age of thirty-five, he made a welcome return to his home club of Swansea, much to the delight of his legion of admiring fans, and moved to live in Bishopston.

The crowning time of his international career was probably at the 1958 FIFA World Cup, held in Sweden. Ivor had scored in both of the play-off games against Israel and scored two further goals at the finals, against Mexico and Hungary. Wales famously reached the quarter final of the World Cup, only to be beaten 1-0 by Brazil, whose

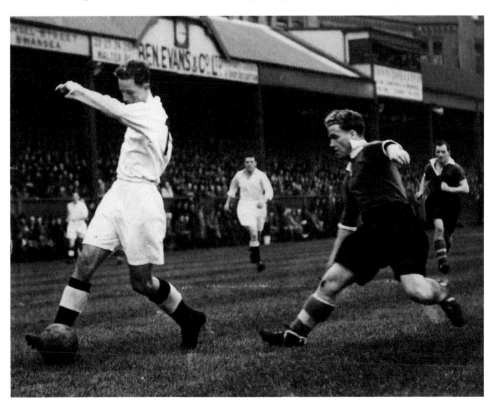

The elegant inside forward (Swansea 1, Cardiff City 0, Vetch Field, Swansea, 4 November 1950).

goal was scored by the seventeen-year-old Pele. It was reckoned at the time that Ivor Allchurch was good enough to play in any of the teams at the finals, including Brazil. Among the many accolades Ivor received in his career was the BBC Welsh Sports Personality of the Year in 1962. He was also inducted into the Welsh Sports Hall of Fame and the English Footballers' Hall of Fame.

He married his sweetheart, Esme, in 1953, and they settled in Mumbles. They were to have two sons, John and David. After retiring from professional football at the age of fifty, Ivor and Esme continued to live together in Bishopston until he sadly passed away at home in 1997, aged sixty-seven.

In 1998, a list of 'Football League 100 Legends' was selected by a distinguished panel of journalists from all those who had played in the previous 100 years. Ivor Allchurch and three other Swansea boys – Trevor Ford, John Charles and Cliff Jones – were included in this list of all-time greats. A statue in Ivor's honour was unveiled at Swansea's Liberty Stadium in 2005 and there are a couple of roads named after him in Newcastle. A recent new development in Caswell has been named 'Allchurch Gardens' in his honour.

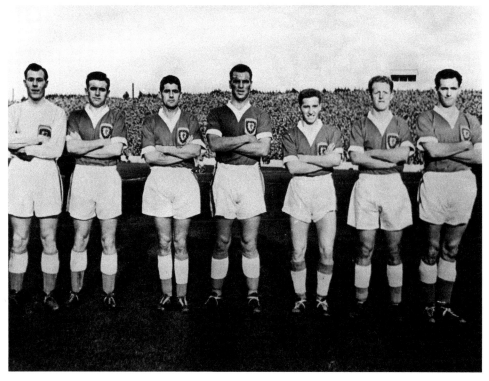

Swansea-born greats (left to right): Jack Kelsey, Terry Medwin, Trevor Ford, John Charles, Cliff Jones, Ivor Allchurch, Ray Daniel.

John Wesley in Gower

John Wesley (1703–91), the renowned founder of the Methodist Church, was a notable leader in the evangelical revival, which he led from within the Church of England during the eighteenth century. He travelled many thousands of miles through Great Britain and Ireland, spreading 'the word' by preaching to gatherings of people in the open air. He felt that in this way he could reach many more people, particularly those who would never go into a church. His evangelising mission lasted for around fifty years and he was described as 'the best loved man in England'. Wesley visited Oxwich in Gower a number of times between 1762 and 1773, following which the Evangelical Revival gained a firm foothold. By the nineteenth century Methodism became firmly established in several Gower villages, notably in Horton. Services were often led by non-ordained, lay preachers who no doubt addressed their gatherings with considerable passion.

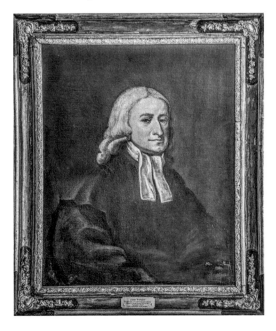

Portrait of John Wesley. (Courtesy of Dsdugan under Creative Commons 1.0)

It seems incredible now that, to reach Gower, John Wesley crossed over the Burry Estuary on horseback, making the hazardous 10-mile crossing from Pembrey to Whiteford Point at low tide. He was very fortunate to have the aid of an experienced guide to navigate the dangerous quicksands and fast-moving streams when he crossed the sandbanks of the estuary. Since those days the estuary has been dredged, making such a journey impossible now. Wesley recorded his eventful journey in his journal dated 31 July 1764, saying he arrived in Oxwich 'well tyred'. There was no public house in Oxwich at the time so Wesley was obliged to stay at a cottage where the woman was unable to offer any refreshment other than 'a dram of gin'! (Wesley was ambivalent about alcohol but some Methodist churches later became champions of the temperance movement.)

The cottage in Oxwich where Wesley lodged and preached is now known as 'The Nook' and a plaque records his visits there. He felt that the people of Gower were 'the most plain, loving people in Wales', which made them very receptive to 'the word'. The fact that this was an English-speaking area also made it easier for him to preach and he addressed gatherings in several Gower villages. He came to Oxwich and Gower on around five occasions in all and also visited Oxwich Castle, which he described as 'the tallest building in Wales'.

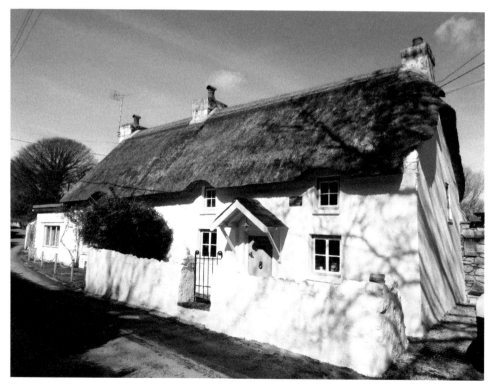

The Nook, Oxwich, where John Wesley lodged and preached on five occasions.

Killan Colliery Disaster

The once-flourishing north Gower coalfield at one time included a number of mines in the Dunvant and Killay areas. One such mine was the Killan Colliery in Dunvant. It began operating in 1899 and became one of the largest in the locality, employing over 750 men at its height, mostly coming from the Dunvant village area.

One fateful day, Thursday 27 November 1924, the village was rocked by disaster when the mine was flooded by a sudden and unexpected inrush of water that tore

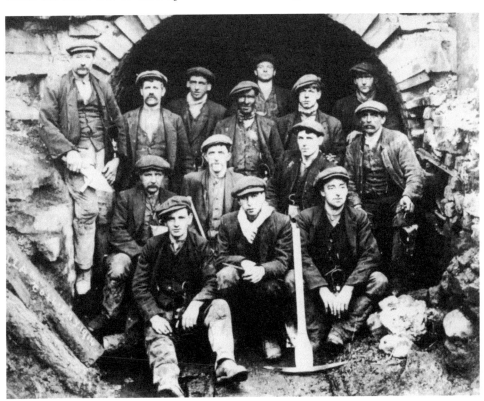

A group of Killan Colliery miners in 1914 at the mineshaft that flooded some ten years later.

out the roof timbers and trapped some of the men working there. There was an immediate response from all the available village menfolk including members of the local male choir, many of whom worked in the mine. Due to the urgent and heroic response, most of the eighty-two men working on the shift managed to escape but two were killed instantly in the roof collapse and eleven men were left trapped in the deep drift. Pumps were rushed in from neighbouring mines and frantic efforts were made over the following days to reach the entombed miners.

The plight of those trapped made national headlines, and the day after the disaster the mayor of Swansea, and also the touring All Blacks rugby team, visited the site to express sympathy with the local community. Some fifty hours after the initial collapse, eight men who'd managed to survive in an air pocket were miraculously located. The news of their survival was quickly conveyed to Ebenezer Chapel in Dunvant, where the packed Sunday service was interrupted to give the welcome news. It wasn't until over a month later that three other bodies were recovered, confirming the five sad fatalities caused by the flood.

The Killan Colliery was abandoned soon afterwards and its entrance was permanently sealed. Nature has since taken over the site, which is now a pleasant little green valley. A memorial to the five lost miners may be found at the site of the former Dunvant railway station, not very far from Ebenezer Chapel.

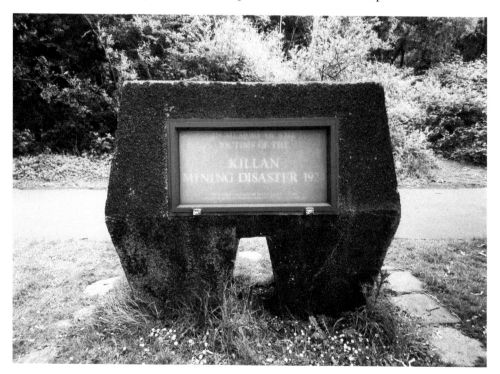

The memorial at Dunvant to the victims of the Killan Mining Disaster of 1924. (Courtesy of Phil Davies)

Langland Bay

Langland Bay has always been my favourite seaside place, ever since my first visits there on Sunday school outings from the valleys. Little did I know in those childhood days that one day I would be fortunate enough to live nearby, able to stroll down to Langland at any time. Familiarity never dims the pleasure of walking along the lovely beachfront and passing the immaculate rows of green and white beach huts overlooking the bay.

Watching over the scene, like a proud parent, is the impressive turreted 'castle' built by the wealthy Crawshay family of ironmasters as a summer retreat in

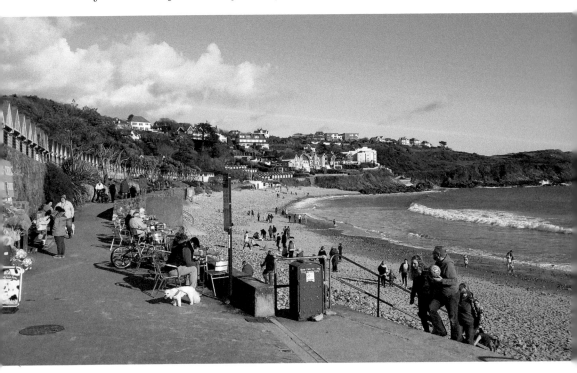

Langland Bay on an exceptional February half-term in 2016.

the 1850s. Originally named Llan-y-llan, the marine villa was later enlarged to become the Langland Bay Hotel; it offered luxury accommodation, fine cuisine and splendid facilities, including tennis courts. Its heyday was in the late Victorian and Edwardian periods, but the grand hotel unfortunately encountered financial difficulties. The main building was acquired in 1922 by the Working Men's Club and Institute Union to become a convalescent home for sick and unfortunate workers. The annexe and coach house became a remodelled Langland Bay Hotel which prospered until the late 1980s when it was pulled down to create apartments. After the convalescent home closed in 2004, the main building was also converted to luxury apartments.

The wooden beach huts are a particularly fine feature of Langland Bay and at one time there were also green canvas beach huts on the top side of the beach. These disappeared by the 1980s, unfortunately having been vulnerable to heavy storm tides and security problems.

Langland Bay is very popular with surfers due to its easy accessibility and variety of challenging waves that can be ridden at different tide levels. The Surfside Café on the beach is well named and at the other end of the promenade the popular Langland's Brasserie is cleverly designed to blend in with the beach huts. The tennis courts remain, these days available for public use. To the east of the main bay is Rotherslade, or 'Little Langland', accessible just along the coast path or from the beach at low tide, while to the west is Langland Bay Golf Club up on the headland, enjoying great views in all directions.

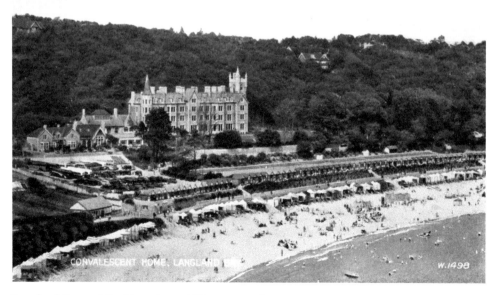

Langland Bay and the Convalescent Home, *c.* 1938.

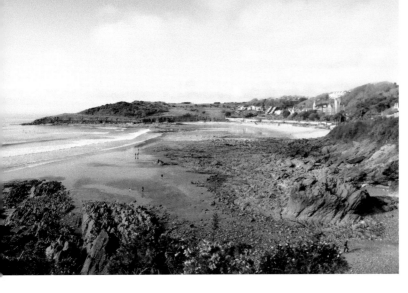

Langland Bay from Rotherslade at low tide.

Llanrhidian

The choice of which north Gower village to feature in my A to Z selection was a difficult one, but in the end I decided to plump for Llanrhidian. It's an interesting and pleasant place to visit and has great views over the salt marshes and sands of the Loughor Estuary. It has a Norman church, standing stones, two ancient pubs, and a history of water mills and weaving.

Llanrhidian's attractive church was once the location of a sixth-century monastic cell and is dedicated to two Celtic saints – St Illtyd and St Rhidian. The church's

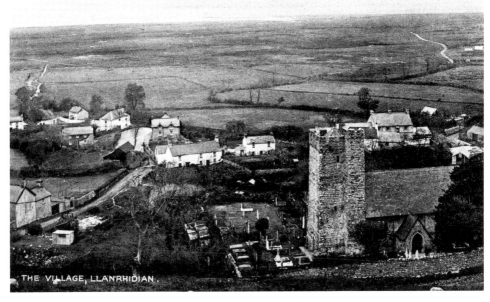

THE VILLAGE, LLANRHIDIAN.

The village of Llanrhidian overlooking the salt marsh and estuary.

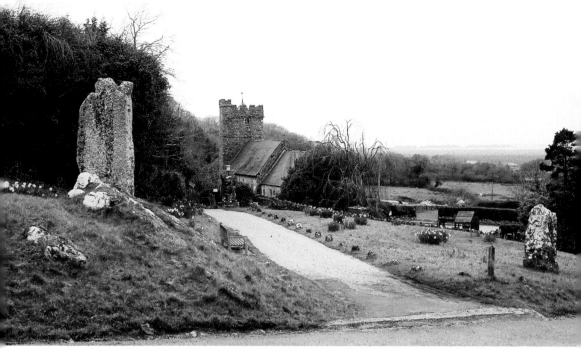

Llanrhidian Church and standing stones in springtime.

present tower and chancel are thirteenth century, but the nave was substantially rebuilt in the 1850s. There's a mysterious ninth-century, carved 'leper stone' in the church porch that was unearthed near the church tower in the nineteenth century and which may have Irish or Viking origins. On the green outside the church stands an eleventh-century Celtic or 'wheel cross', which may once have been used as a pillory or whipping stone for wrongdoers. A second ancient standing stone stands lower down and this was raised in its present position in 1884 by a dozen local volunteers who were rewarded with a pint of beer each for their efforts.

Fairs were once regularly held on the village green, where livestock was bought and sold and itinerant hawkers, shoemakers and hatters bartered their goods, accompanied by wandering minstrels, including fiddlers and organ grinders. The fair day was clearly quite a boisterous affair and the two eighteenth-century taverns, the Dolphin and the Welcome to Town, no doubt welcomed the many fairgoers and contributed greatly to the festivities.

The village stream used to feed two ancient corn mills. Llanrhidian's Higher Mill was abandoned in the nineteenth century but the Lower or Nether Mill overlooking the estuary continued until the middle of the twentieth century. Its disused mill-house and millpond are down below the Dolphin. The weaving industry was once very active across north-west Gower and was carried on in Llanrhidian from the early seventeenth century when handlooms were in use. In around 1820, the old farmstead of Stavel Hagar (Staffal Haegr), situated between the cliff and the marsh, started utilising water power to operate a woollen mill. There was a long leat running westwards from the village to feed the water wheel at the factory where local people were employed in spinning, dyeing and weaving, producing high-quality blankets, shawls and quilts. Stavel Hagar operated until 1904 and its remains are along the lane leading to the marsh.

Mumbles Mile

Mumbles is well known for many things, not least for the famous (or infamous) Mumbles Mile. It's known the world over. I once met a man in a bar in Taiwan who fondly recalled his trip down the Mumbles Mile when he'd visited in his youth. The 'Mile' is generally regarded as the stretch of promenade from Oystermouth Square to the pier. In today's pub terms it would be from the White Rose to the Pier Hotel (these days called Copperfish) and its name probably derives from when it was a popular student pub crawl in the 1970s. Its history, however, goes back much further.

Let's go back in time to around the 1880s when the Mumbles Railway terminus was in Oystermouth, near where the Dairy Car Park now stands. Thousands of people would descend on Mumbles on the train, particularly on Sundays, taking advantage of a loophole in the Welsh Sunday Closing Act. Bona fide travellers, travelling more than 3 miles, were allowed to purchase 'refreshments' on Sundays and, of course, Swansea to Mumbles was 5 miles on the train. Most of these people were not genuine travellers, they just wanted to come to Mumbles to drink in the many pubs. They were referred to as 'bona fide humbugs'! They didn't have to go far from the station for their first drink. Clustered around the terminus were the Talbot Arms, Rhondda Hotel and Oystermouth Hotel. A short distance away were the White Rose and the Nags Head. And they were only at the start of the Mile! Then it was the Marine Hotel, Waterloo, Antelope, Prince of Wales, Albion, Greyhound, Ship & Castle, Mermaid, Beaufort Arms, George and the Pilot, among others (Mumbles Pier hadn't yet been

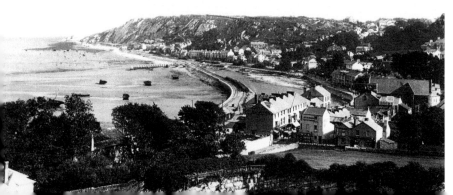

A view of Mumbles and the 'Mile' in 1893 before the pier was built.

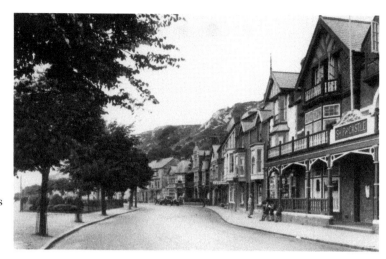

Along the Mumbles
Mile in 1925 with
the Ship & Castle
and the Mermaid.

built). No wonder a genuine traveller to Mumbles commented, 'Drunkenness seems
to be the bane of the village, vacancy of mind being the consequence'.

In more recent times, the Mumbles Mile has been popular with people keen to take
on the challenge of having a drink in every pub, including many hen and stag parties.
Perhaps it got a bit of a bad name as a result but, anyway, all that has changed (the
revellers now tend to go to Swansea instead). The Mumbles Mile has become more
civilised, with a range of restaurants and café-bars, takeaways, hotels and guest
houses and upmarket seafront apartments. There are still pubs, of course, some very
good ones, and several recently opened bars that also serve good food.

There are probably still a few intrepid drinkers who like to try out the Mumbles Mile
and, at the time of writing, a challenging itinerary (excluding hotels and restaurants)
could be: White Rose, Dark Horse, Village Inn, The Tavern, Bar 1887, Elwyn, The
Ponderosa, Ty Cwrw, The George, Pilot and Copperfish on the pier. Happy staggering!

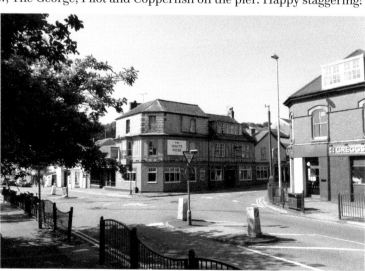

White Rose at
the start of the
Mumbles Mile,
deserted during
lockdown in
May 2020.

Mumbles Pier

On 10 May 1898, the Mumbles Pier and Pier Hotel were opened to great acclaim when the ribbon was cut by Lady Jenkins, the wife of Sir John Jones Jenkins, chairman of the Mumbles Railway & Pier Company. The Mumbles Railway line was extended to the pier from the original terminus at Oystermouth, and soon thousands were flocking on the train to this wonderful new attraction. The pier was 835 feet long and featured a bandstand, landing stage for steamer trips and fishing platforms at the pier end. There was an impressive glass pavilion at the landward end, which held 1,000 people and featured grand concerts and shows. Famous opera singers of the day appeared there and choral and instrumental competitions were also held. Bands played on the pier, including Cyfarthfa, Black Dyke and the Grenadier Guards. To celebrate the centenary of the Mumbles Railway on 30 June 1904, a grand fireworks display was held at the pier.

The huge crowds clearly contained the odd troublemaker because on August bank holiday in 1906, the piermaster, Captain Twomey, was assaulted when he was attempting to escort a rowdy seaman out of the second-class bar. The miscreant was subsequently fined 40s. During this period popular steamer excursions sailed from the pier to exotic locations like Ilfracombe, Tenby, Clovelly, Weston-super-Mare and Lundy Island. These trips continued in later years.

In 1937, the Amusement Equipment Company leased the pier and Hancocks Brewery took over the Pier Hotel. As well as the amusements, facilities included a restaurant, ballroom and sun lounge and the hotel later included the Toby Bar, Salty Bar and Collectors Bar. The Mumbles Railway was electrified in 1929 and, in 1954, to celebrate the historic railway's 150th anniversary, horse-drawn, steam and electric

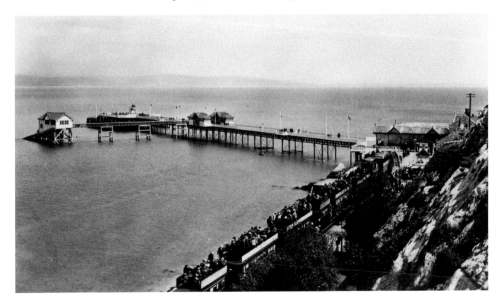

Crowds flocking to Mumbles Pier on the train in the 1920s.

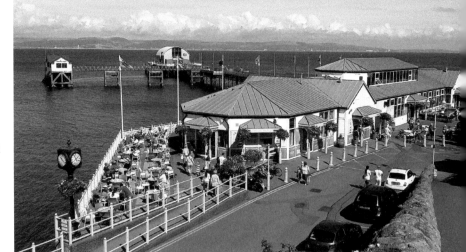

The café and amusement arcade at Mumbles Pier on a warm summer's day in 2015.

trains ran on the railway to the pier. Sadly, the much-loved Mumbles Railway was closed in 1960, despite a petition to the House of Lords.

In the 1970s, reflecting modern trends, the ballroom was extended to become Cinderella's disco – very popular with younger people in the area. Many celebrities visited the pier, including Harry Secombe, who met his wife Myra at a dance there. Other celebrity visitors have included Max Boyce, Clive Dunn, Harry H. Corbett and Windsor Davies. The centenary of the pier was held in 1998 and, to mark the occasion, a celebratory beer called 'Pierhead Special Ale' was brewed for the Mumbles Beer Festival.

The pier has had a long and important association with the Mumbles lifeboat and in 1916, a slipway was constructed on the pier, with a lifeboat house added six years later. A magnificent replacement lifeboat house was opened on the end of the pier in 2014, and now houses the state-of-the-art 'Tamar'-class lifeboat.

Today's pier is Grade II listed and offers many attractions, including a café (with great views), an amusement arcade and a bowling alley. The Copperfish bar and restaurant has opened where the old Toby Bar used to be. The iconic pier is presently undergoing a major renovation and it is planned to add a foreshore boardwalk in due course. Further substantial redevelopment has also been planned to include holiday accommodation at the site.

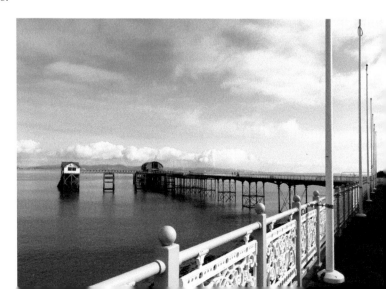

Today's Mumbles Pier with the old and the new lifeboat houses.

Newton Village

Just about a mile up the (steep) hill from Mumbles is the village of Newton and it would be remiss of me not to include it here because it's been my home for the last thirty-odd years. Newton has everything a village could wish for. There's a church and a chapel, both well-attended, there's a garage where you can get your car fixed and a pub that does food. There's also a school, an excellent butcher and a paper shop that sells most things. And there's a superb village hall where loads of activities happen, and where you can get books and coffee. Langland Bay and Caswell Bay, and Mumbles, are all within walking distance and a regular bus service will take you into Swansea. So, it's a great place to live.

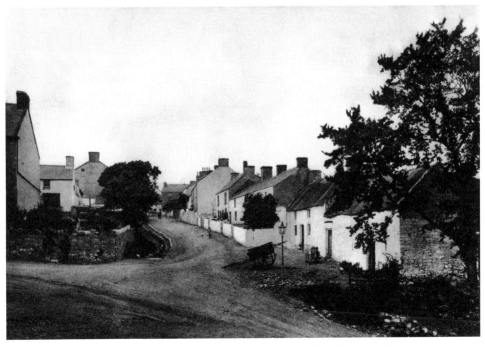

An early photograph of Newton on the corner of Nottage Road and Newton Road.

In earlier days, the village was a mixture of cottages and farmhouses and it was described in 1860 as 'a quiet and quaint little village of the olden time'. It was referred to as 'Upalong' by old Mumbles folk (as distinct from 'Inalong' and 'Outalong', which are down in Mumbles itself). Newton was visited by Methodist reformers in the 1740s and John Wesley is said to have preached here in in 1758, a few years before his visits to Oxwich. The present Paraclete Chapel (Congregational) was established by Lady Barham (see Fairyhill, p. 22) in 1818 and was rebuilt and extended in 1880. When Dylan Thomas was a small boy, his Aunt Theodosia ('Dosie') was married to the minister, Revd David Rees, and Dylan used to stay with them at the Manse and attend the Sunday school at Paraclete. He called Newton the place 'where the aunties grew'. His lifelong friend, the composer Daniel Jones, also lived in Newton for many years (see earlier entry, p. 15). The old Manse is now occupied by bookseller Jeff Towns, a noted authority on Dylan Thomas.

St Peter's Church was consecrated in 1903 to cater for the demands of an expanding population in the parish of Oystermouth. The church continues to play an important role in the spiritual and musical life of the area with its ambitious incumbent and fine church choir. It also hosts the excellent Mumbles A Cappella choirs, comprising children's, youth and senior choirs. The Newton Inn is the only pub remaining in the village, having been established as the Ship & Castle in the early 1840s. The earlier Ship Inn and Caswell Inn have long since disappeared and the Rock & Fountain recently closed and is presently being converted into residential dwellings.

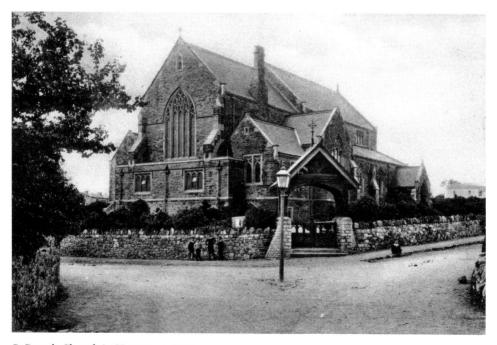

St Peter's Church in Newton, *c.* 1914.

The well-known poet and hymn writer Frances Ridley Havergal (1836–79) lived in Caswell Bay Road for the last year of her life and wrote famous hymns such as 'Take My Life and Let It Be' and 'I Gave My Life for Thee'. She was a prominent temperance campaigner and much loved by the children of the village, including her 'donkey boys' who looked after donkeys in the stables in Nottage Road. Newton's village green is known locally as 'Picket Mead', where, it is said, a party of Cromwell's soldiers encamped at the time of the march into South Wales by the army of the Commonwealth, on the occasion of the 'dismantling' of Oystermouth Castle.

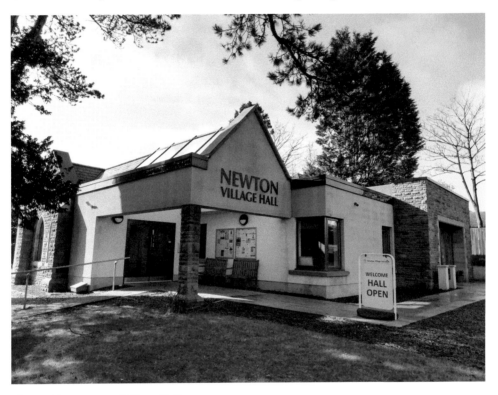

The excellent Newton Village Hall.

O

Oystermouth Castle

Oystermouth Castle's original foundation is often ascribed to the Norman conqueror of Gower, Henry Beaumont, Earl of Warwick; however, its earliest recorded date is 1116, when the castle was burned down by the Welsh. This was its fate again on two occasions in the thirteenth century, including in the 1250s during the war with Llewellyn ap Gruffydd. The old wooden castle was rebuilt in stone in the early 1280s when the de Braose family, lords of Gower, constructed the central buildings and keep. Edward I stayed at the castle in 1284 on his journey through Wales after the defeat of Prince Llewellyn, but there was a final defiant attack by the Welsh a year later when the castle was again extensively damaged. The chapel tower, with its fine traceried windows, was added in the fourteenth century when the castle was in the occupation of the de Mowbray family. Although it was a country seat – as well as a prison and courthouse – around this time, it eventually became ruinous. The castle also took a battering from Cromwell's troops during the Civil War.

The castle was later in the hands of the Somersets, the family of the Duke of Beaufort, on whose behalf an important restoration was undertaken in the early 1840s. In 1860, however, it was described as 'an old broken-down castle clad in a respectable mantle of ivy', and in 1888 the *Mumbles Chronicle* reported on a plan to convert Oystermouth Castle into a grand hotel. This would 'command a splendid sea view, especially when the tide was in'. The name 'Oystermouth Castle Hotel' was thought to be a good one, but the cost of taking down the walls and building a modern hotel out of their material would be great. It was also suggested that the Duke of Beaufort may not be agreeable to converting the crumbling ruins.

In much more recent times the castle has undergone a multi-million-pound refurbishment (completed in 2011), and now attracts very many visitors who can appreciate its long history and enjoy the great views from the ramparts. The castle also hosts special events and is spectacularly floodlit at night. It remains, of course, the spiritual home of the ghostly White Lady of Oystermouth.

The Oystermouth Castle of today still stands proudly on the hill looking over Mumbles, nearly a thousand years after its foundation, and is much loved by locals and visitors alike.

Oystermouth Castle in the Edwardian period, still 'clad in a respectable mantle of ivy'.

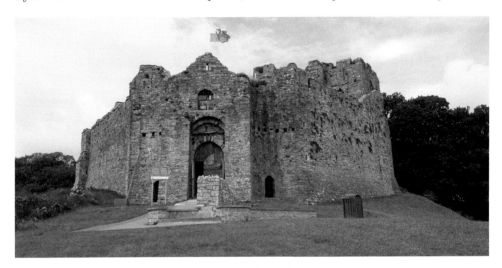

Oystermouth Castle in recent times – very popular with visitors.

Oysters

Oystermouth didn't get its name by accident. Oyster beds were found off the Gower coast in Roman times and by the seventeenth century the local oyster fisheries were said to be the finest in Great Britain. The famous Mumbles oyster industry saw its peak during the nineteenth century and the heyday was probably in the 1860s and early 1870s. In 1860, oysters were the staple commerce (and staple diet) in Mumbles and the oyster dredgers received 9s per 1,000 oysters, which were resold in England to retailers at 25s – big profits were clearly being made. In the peak year of 1871, over

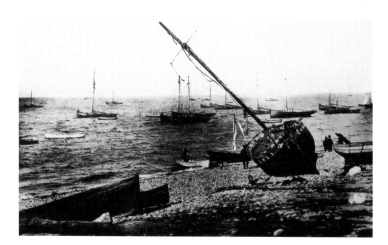

Mumbles oyster boats, *c.* 1880.

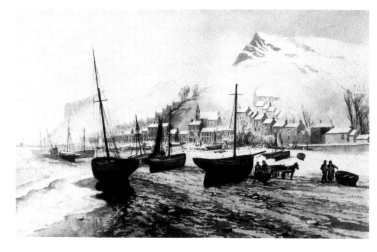

Oyster boats at 'Mumbles in a Snowstorm'. (Oystermouth Historical Association archive, from Jan Burgess, Australia)

170 oyster skiffs were dredging and they landed over 18 million oysters in Mumbles in that year. Around 600 men were employed in the trade, earning approximately £6 per week, which was good money (although much of it was probably squandered in the numerous hostelries along the Mumbles foreshore). The celebrated diarist Revd Francis Kilvert commented on a visit to Mumbles in 1872 that 'the great fleet of oyster boats ... was coming in round the lighthouse point with every shade of white and amber sails gay in the afternoon sun' – a vivid word-picture of the scene at the time.

The oyster season ran for eight months from 1 September to 30 April and the catches were held in 'perches' along the shore until required for sale (the remains of the perches may still be seen at low water). Fishing was suspended in the summer to allow for spawning, although stocks could be held in plantations out in the bay during this period. To celebrate the start of the season in September there was always a big oyster fair, where the skiff owners would provide bread and cheese and casks of ale for their crews and there was much revelry. There were also games for the children who would make grottos and shell houses from the discarded oyster shells.

Mumbles oysters were sent by rail to places like Bristol and London as well as being sold locally in stalls and oyster bars along the front. Some oysters were even pickled and sold in jars to tourists. The prime minister, W. E. Gladstone, famously sampled Mumbles oysters during his visit in 1887 and the bar in question was subsequently renamed Gladstone's Oyster Bar in his honour – a name that endured long afterwards.

Sadly, by 1875, catches were becoming reduced due to overfishing and by 1889 the fishery was 'in a very sad condition'. There was a brief revival at the end of the century, but the decline continued. Pollution from industry and sewage contributed to the problem and an outbreak of disease in 1920 virtually finished oyster dredging in Mumbles. There have been worthwhile efforts in recent times to re-establish oyster beds in today's much cleaner Swansea Bay and it is very much hoped that the industry may be revived. The Mumbles Oyster Fair has certainly been revived in recent years, celebrating a great local tradition and offering this delicious delicacy and much more in a convivial festival atmosphere. The most recent Oyster Festival was held in October 2019 at the Ostreme Hall in Mumbles.

Oyster table at the Mumbles offering tasty treats to the charabanc passengers.

The 2019 Mumbles Oyster Fair was held at the Ostreme Hall and attracted packed crowds. (Courtesy of Mumbles Development Trust)

P

Penmaen

Penmaen and Nicholaston Burrows form a particularly beautiful National Trust section of coastline in south Gower and the area holds some fascinating history as well as having magnificent scenery. The location includes the Great Tor and Tor Bay, and the award-winning Three Cliffs Bay, but it is the Penmaen Burrows above the cliffs that have the archaeological and historical interest.

The Burrows were once the location of the lost village of Stedworlango, which became 'besanded' in storms in the fourteenth century and was subsequently abandoned. The remains of an ancient Christian church may be found here, as well as a megalithic burial chamber said to date from around 3000 BC. This neolithic communal tomb has central and side chambers, and its fallen capstone weighs around 7 tons. The ringworks of an early Norman defensive structure may also be found nearby. The promontory fortress consists of a massive encircling bank fronted by a deep ditch and is known as 'Penmaen Old Castle'. It was built in the twelfth century, although it was probably attacked and burnt down by the Welsh before the middle of the thirteenth century. Unlike other Gower castles, it was never rebuilt in stone. The short walk to Penmaen Burrows to discover these interesting remains is rewarded with stunning views over the coast.

Today's village of Penmaen nestles below Cefn Bryn hill and its little church is dedicated to St John the Baptist. Other prominent buildings here include the Victorian

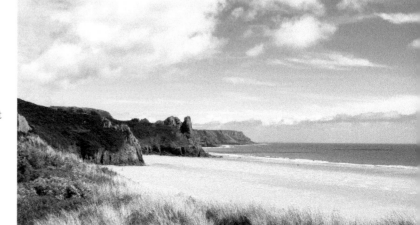

Tor Bay and the Great Tor with Pennard Cliffs beyond. (Courtesy of Phil Davies)

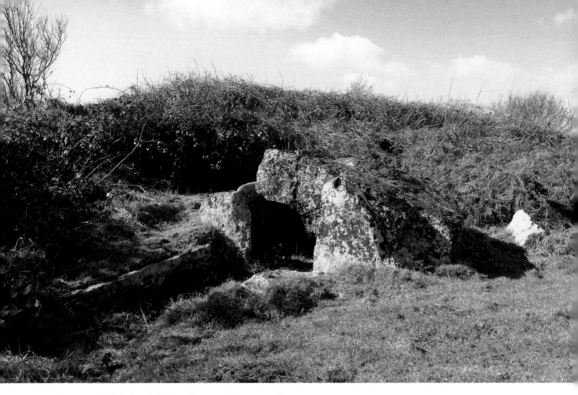

The megalithic burial chamber on Penmaen Burrows.

ex-workhouse – once known as the 'Gower Union' because it accommodated paupers and other unfortunates from a union of parishes. It later became a nursing home and residents included the famous Gower folk singer Phil Tanner, known as the 'Gower Nightingale', who died here in 1950. It is now the Three Cliffs Care Home and enjoys great views, as does the imposing Nicholaston House nearby, which was built by a sea captain in the 1880s. This became a hotel for a number of years and is now a Christian retreat centre.

Pennard and Pwlldu

The National Trust area of Pennard, Pwlldu and Bishopston Valley encompasses the magnificent high cliffs between Three Cliffs Bay and Pwlldu Head and the secluded but historically important Pwlldu Bay with its attractive sand and pebble beach. The delightful Bishopston Valley winds inland from Pwlldu towards the village of its name. This is great walking country and the grassy clifftop route may be followed both ways from the National Trust car park at Pennard with great views of the cliffs, east and west.

 The bay at Pwlldu was once a busy little port from where the limestone quarried on Pwlldu Point was exported across the Bristol Channel to north Devon and Cornwall. In the eighteenth and nineteenth centuries many sailing ships would be anchored in the bay waiting to be loaded. These were generally two-masted vessels, a cross between a brigantine and a schooner, and were known as 'muffies' by the north Devon sailors. The iron rings on the rocks where they were once tied up may still be found at Pwlldu

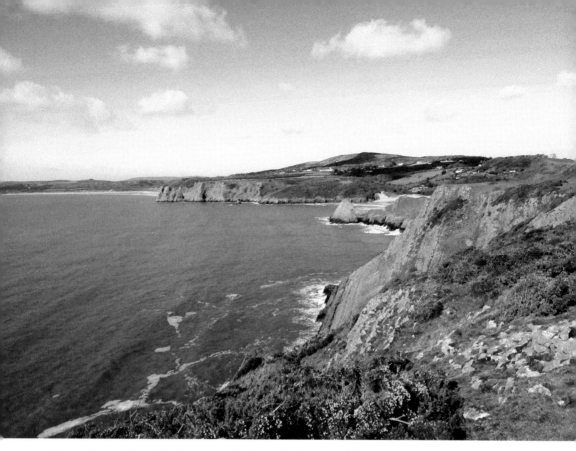

Above: Pennard Cliffs looking towards Three Cliffs Bay and the Great Tor.

Below: The track leading down to Pwlldu Bay.

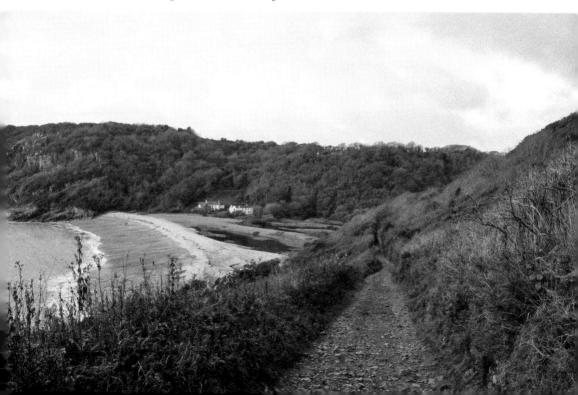

The old bridge over the Bishopston stream at Pwlldu with Beaufort Inn and Ship Cottage in the background, *c.* 1910.

Point. There were several pubs in Pwlldu in its heyday, including the Ship and the Beaufort, that catered for the quarrymen and the sailors as well as the local farmers. Other hostelries in the valley such as the Bull and the Star are lost in the mists of time.

Smuggling was a regular activity in this remote spot, as well as at nearby Brandy Cove (well named!), particularly in the latter half of the eighteenth century. The casks of brandy, rum and 'Hollands' and bales of tobacco would be hauled by packhorse up the valley and along Smugglers Lane to Great Highway and Little Highway Farms in Pennard, which were notorious distribution centres. A lucrative trade was carried on for nigh on fifty years until a day of reckoning arrived in 1804. After learning of the arrival of a cutter in the bay and assuming a landing would be made that evening, a substantial party of excisemen raided the Highways that night. After thoroughly searching the premises they eventually discovered a series of hidden trapdoors leading to spacious cellars below where nearly 3,000 gallons of spirits were found. This resulted in the apprehension of the gang leaders and dealt a severe blow to the smuggling activities at the time. Nevertheless, contraband continued to flow for some time afterwards and some of it, no doubt, found its way into the taprooms of the Pwlldu taverns.

The Bishopston Valley follows the stream in a lovely wooded setting between rocky limestone outcrops and there is much to savour on a walk here. The stream vanishes underground into the limestone rock towards the top end and there are caves and old silver and lead mine workings to attract interest. After a walk through the valley and, perhaps, a visit to St Teilo's Church in Bishopston, some welcome refreshment may be enjoyed at the Joiners Arms or the Valley Hotel.

Queen of Reynoldston

The King Arthur Hotel stands proudly overlooking the Higher Green in Reynoldston. Back in 1920 the hotel was taken over by Miss Violet Howell, an extraordinary lady who was widely known as the 'Queen of Reynoldston'. Miss Howell was an imposing figure who insisted on good behaviour in her public bar, but was a generous hostess, particularly to those who were in her good books. She managed the hotel up until the early 1940s and there were few village events and celebrations in which she was not heavily engaged. Perhaps the most notable event that Miss Howell became involved in was the Penrice Pageant of 1924, which is described in detail in an article by Robert Lucas in *Gower 48*.

Miss Violet Howell, the 'Queen of Reynoldston' (from *Reynoldston* by Robert Lucas).

The great pageant was organised to raise funds for the West Gower Nursing Association and was directed by Lt Col Ernest Helme of Hillend, Llangennith. The event was staged in front of the Norman castle at Penrice, and each of the local parishes was given the task of enacting a costumed show to tell the story of their local history and traditions. Miss Howell was the obvious choice to direct the Reynoldston episode, which was, of course, on an Arthurian theme. It featured Merlin the Magician 'practising unholy rites' at Arthur's Stone and included King Arthur and his queen with Rheged ap Urien and his sorceress wife appearing on horseback. A large company of knights also appeared and almost ninety of Reynoldston's villagers took part in the performance. The end of their act featured a mock-up of Arthur's Stone rolling down to the estuary for its traditional drink. The entire pageant featured over 600 participants and the show was reported by the *South Wales Daily Post* to be 'a gorgeously coloured, wildly picturesque procession of knights and Vikings and jesters, seneschals, nuns, peasants, bishops, saints, figures of Arthurian legend, fiddlers, villagers, monks, crusaders and smugglers' all in period costume, with their armour and weapons, and with 'gorgeously caparisoned steeds'. It was 'Gower's past living again' and it all ended with a massed performance of *Land of Hope and Glory*. The pageant was a huge success despite the inclement weather and the following day a celebratory party and dance was held at Reynoldston's newly built village hall.

In the early 1930s, Swansea Little Theatre players performed at Reynoldston village hall and the cast included Dylan Thomas. On this occasion, Dylan led some of the cast up Cefn Bryn hill and told them he was trying to invoke evil spirits at Arthur's Stone. He led them around the stone, chanting all the time, making up a spell, and his acting was so convincing that one of them 'nearly passed out with fright'! They all repaired to the King Arthur Hotel afterwards for drinks and I wonder what the Queen of Reynoldston made of young Dylan.

R

'Red Lady' of Paviland

The 'Red Lady' of Paviland wasn't really a lady at all. When William Buckland uncovered the burial of a partial skeleton in Paviland Cave in 1823 it was covered in red ochre and buried with carved ivory trinkets, and he assumed the remains were female. At the time, Buckland was Professor of Geology at Oxford University (he later became Dean of Westminster) and he was also a creationist who did not believe that humans could have existed before the biblical Great Flood. He dated the skeleton to Roman times, suggesting she had been a Roman prostitute or witch associated with a Roman camp above the cliff (this was actually an Iron Age camp). Buckland was

Above left: Skeleton of the 'Red Lady' of Paviland. (Courtesy of Oxford University Museum of Natural History)

Above right: Paviland Cave with a view along Foxhole Slade. (Courtesy of Coflein)

drastically inaccurate in his assessments. The skeleton was subsequently proved to be much, much older and to be that of a young man in his early twenties. Successive radiocarbon dating procedures have shown that the Red Lady was buried some 34,000 years ago, making this one of the oldest known ceremonial burials in Western Europe.

Paviland Cave (also known locally as Goat's Hole) is a sea cave situated in the limestone cliffs at Foxhole Slade, around halfway between Port Eynon and Rhossili. Buckland was drawn there after some locals had discovered a large mammoth's skull in the cave and he undertook an extensive dig, finding the headless skeleton and some small periwinkle shell beads and ivory rods and rings, all stained with red ochre. Subsequent excavations, mainly in 1913, found around 4,000 worked flints and flakes from the Upper Stone Age, as well as some reindeer and wolf's teeth perforated for a necklace, an ivory pendant carved from the tusk of a mammoth, and ivory bracelets and needles. The animal bones found included extinct species such as woolly rhinoceros, mammoth, extinct ox, cave bear and cave hyena, which were all present in the late Paleolithic period. The stone tools and burned bones suggest that the Red Lady could have been one of the hunters who used or occupied the cave during many thousands of years of prehistory.

Paviland Cave is estimated to have been around 70 miles inland at the time of the burial, overlooking a vast plain during a warmer period in the last Ice Age. The cave itself was originally formed in earlier times when the sea levels were considerably higher. It is undoubtedly one of the richest archaeological sites in the British Isles and the remains are among the oldest human remains ever discovered in the UK. The partial skeleton of the Red Lady may be seen at the Oxford University Museum of Natural History together with some of the finds from the cave. There's also a replica of the skeleton and other artefacts at Swansea Museum, with further items housed at the National Museum in Cardiff.

Rhossili

The village of Rhossili lies at the south-western tip of the Gower Peninsula and is renowned for the 3-mile-long arc of beautiful, golden beach that sweeps northwards, spectacularly forming the western edge of Gower. The beach is part of the National Trust protected area that includes Worms Head, Rhossili Down and the magnificent cliffs of the South Gower coast. From the village the view of Rhossili Beach and the cliffs takes one's breath away, and they attract hundreds of thousands of visitors each year. There's a welcoming National Trust shop and visitor centre in the old coastguard houses overlooking the cliffs.

The locality has seen occupation from very early times, with much evidence of prehistory in the area. As well as Paviland Cave on the coast, there may be found on the eastern slopes of Rhossili Down two fascinating Neolithic burial chambers

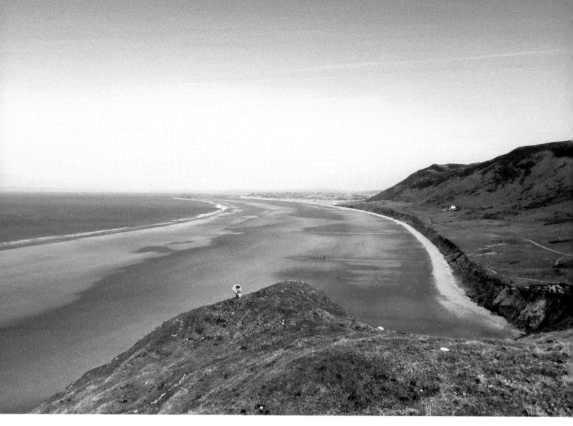

The magnificent sweep of Rhossili Beach with the old rectory halfway along.

known as the Sweyne's Howes. There are also numerous Bronze Age cairns along the summit ridge of Rhossili Down and remains of Iron Age promontory forts on the Rhossili cliffs.

The Romans were probably here, as well as early Christians and Celtic saints, and the Vikings no doubt raided the coast. However, it was the Normans who influenced the south and west of the peninsula the most, creating Gower Anglicana (or English Gower) in the process. The remains of a lost village have been found in the sand dunes at the southern edge of Rhossili Beach, and an early church was located here. The present parish church of St Mary probably dates from the fourteenth century, established by the Anglo-Norman settlers. The old rectory, situated in splendid isolation halfway along the beach, once served the two parishes of Rhossili and Llangennith. Nonconformity came here as early as the seventeenth century, and the fiery Howell Harris and John Wesley are reputed to have preached here in the eighteenth century. The present Methodist chapel between Pitton and Middleton was built in 1887.

The remoteness of Rhossili Bay made it attractive for smugglers, particularly in the late eighteenth and early nineteenth centuries. Many is the tale of huge numbers of kegs of brandy and rum and bales of tobacco being brought ashore on Rhossili sands at the dead of night with the customs men and Sea Fencibles vainly trying to keep a step ahead of the smugglers. One of the arch smugglers at the turn of the nineteenth

Above: The church of St Mary in Rhossili village.

Below: Rhossili Beach and Worms Head from Rhossili Down. (Courtesy of Phil Davies)

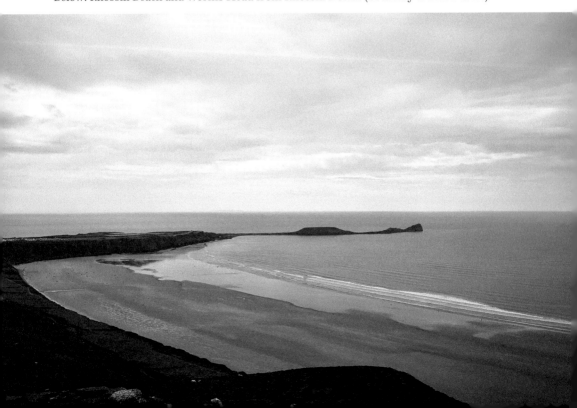

century was William Stote, an innkeeper at Middleton, who no doubt distributed the illicit liquor from his own 'licensed' premises.

Shipwrecks have always been an unfortunate part of the Rhossili story, including the 'Dollar Ship' (described earlier) and the *Helvetia*, wrecked on the beach in 1887 and whose ribs are still exposed at low tide. There are stories of more sinister wreckings from earlier times when wreckers with lanterns would lure unsuspecting ships to their doom on the rocks and then make off with their valuable cargoes.

Rhossili offers much to the visitor and it's no wonder it was a favourite place for Dylan Thomas, who once considered living in the old rectory. The lack of a pub in the village at the time may well have changed his mind.

Salthouse

The Salthouse at Port Eynon is a rare example of the early industry of salt making by evaporation and it is the most intact example remaining in South Wales. The ruined buildings are situated on the shoreline at Port Eynon Point, sited to take advantage of the high salinity of the bay. The high salt content is due to the lack of significant freshwater streams flowing into Port Eynon Bay. The plant was very advanced for its time and was probably built by the locally prominent Lucas family in the mid-sixteenth century. There is clear evidence of its operation during the Elizabethan period and it continued in production until around 1650.

The Salthouse has 1-metre-thick walls and includes a reservoir on the beach that was filled by seawater at high tide. The seawater was held there to allow the

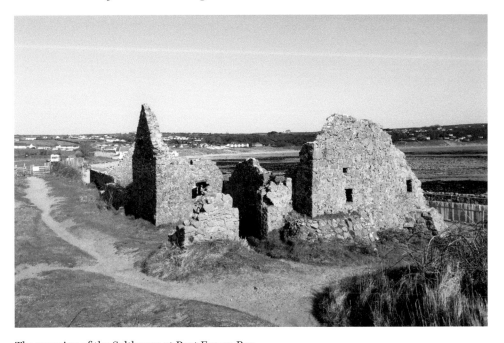

The remains of the Salthouse at Port Eynon Bay.

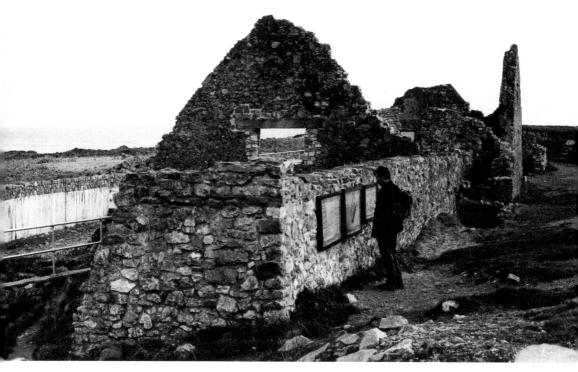

The Salthouse, with display boards, in 1998.

sediment and sand to settle out before being pumped up to a number of shallow iron pans, where it was heated by coal-fired furnaces. The heat evaporated the water, leaving just the salt crystals. The salt was then raked out of the pans and placed in baskets to dry in another room at a higher level. The salt was a valuable commodity and would have been exported from Port Eynon by skiffs that would also have brought in the required coal from local mines. Early evidence exists of other salthouses in the Gower locality, situated at Crofty and Oystermouth, and in Swansea.

The Lucas family left the Salthouse in around 1700 and the fortified upper buildings later became oyster fishermen's cottages, occupied until around 1880. After this, the buildings were abandoned and became ruined and subject to erosion by the sea. In recent years the Salthouse has been established as a Scheduled Ancient Monument and the site has been excavated and restored, winning a Heritage Award. A sea defence wall was completed in 1993 to protect the site from further erosion.

The Salthouse has its legends, of course (in true Gower fashion). In its early days it was alleged to have been the fortress home of John Lucas, smuggler and pirate, who, with his gang, preyed on shipping in the Channel and stored his contraband in the Culver Hole on the other side of Port Eynon Point. There was thought to be a secret tunnel running between the two places. Seven generations later, another John Lucas is said to have discovered paint-bearing minerals in the area and used the Salthouse as a base for exporting this valued material. All this came to an end, apparently, in the

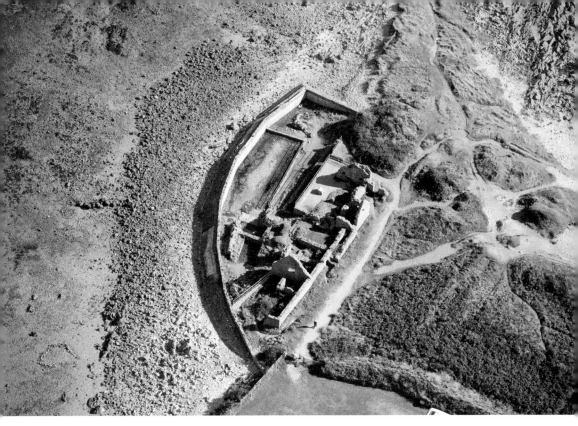

Aerial view of Port Eynon Salthouse. (Courtesy of Coflein)

great storm of 1703, when the Salthouse buildings were destroyed and John's fleet of skiffs was capsized. There are clearly some colourful tales to be added to the history of the salt making.

Sea Fencibles

The Sea Fencibles were a kind of coastal Home Guard, formed mainly of volunteers, who protected the coast and approaches during the Revolutionary and Napoleonic Wars. There was considerable fear of a French invasion at that time and groups of Sea Fencibles were formed all around the country to help counter the threat, both on shore and afloat. In Gower, the headquarters was at Port Eynon, probably because of the seagoing experience of the men living there. Local fishermen and even smugglers were recruited and there was no shortage of volunteers because the Fencibles were exempted from being press ganged into the navy – a common punishment for smugglers. They were provided with uniforms similar to Royal Navy sailors of the day and were also given weapons and provisions. Ordinary Fencibles were paid 1s per day, with officers receiving more. The group would have been under the command of a captain and several lieutenants, who were usually retired or serving naval officers.

The Port Eynon Fencibles, armed with cutlasses and pikes, were trained and drilled on the 'Bowling Green', a level stretch of turf on the burrows. They patrolled beaches

where a French invasion could land and maintained a fleet of their own small vessels, suitably armed, to guard against French vessels off the coast. They also acted as coastguards and lifeboatmen. The Port Eynon Fencibles were formed in 1798 and, although they were briefly disbanded in 1802, they were soon recalled as the threat increased again. The Sea Fencibles were eventually disbanded by the Admiralty in 1810 after the threat of invasion by Bonaparte had passed.

There was an interesting legacy in Port Eynon, as a public house called the Sea Fencible prospered for some time afterwards. It was certainly in business by 1827, when Swansea Quarter Sessions granted a recognisance (licence) to Thomas Clarke, innkeeper at the Sea Fencible alehouse in Port Eynon. The pub was probably on the lane entering the village, just around the bend after the church, on the right-hand side. The last found mention of the Sea Fencible pub is dated 1869, so the old Fencibles could have told their tales there over a tankard of ale for many years after their service to the Crown.

Drawing of a Sea Fencible by
M. Chappell.

The Bulwark

The well-preserved Iron Age hillfort known as The Bulwark occupies the eastern summit of Llanmadoc Hill – the old red sandstone hill that overlooks the villages of Llanmadoc to the north-east and Llangennith to the south-west. The complexity of the site is best appreciated from the air and it comprises an impressive series of ramparts and ditches surrounding a large irregular oval inner enclosure around a hectare in size. Within the central fort there's a smaller rectangular enclosure in the south-east corner that may have been designed to hold livestock. There are subsidiary outer ramparts surrounding the inner defences on all but the steep northern side, with a further straight rampart to the west providing additional defence. The causeway and entrance to the hillfort is on the eastern slope. The multiple series of earthworks suggests that the site may have been developed over several different periods of time. The monument is of national importance and retains significant archaeological potential.

A walk up onto the hill to view the site is rewarded with panoramic views of the western end of the Gower Peninsula, with Whiteford Point and the Burry Estuary to the north and Rhossili Down and Rhossili Bay towards the south. On a lighter

Aerial view of The Bulwark Iron Age hillfort on Llanmadoc Hill. (Courtesy of Coflein)

note, Llanmadoc Hill is often referred to locally as 'Penny Hill' because it has the Kings Head (Llangennith) on one side and the Britannia (Llanmadoc) on the other.

This wouldn't be Gower without another legend, and this one relates to Tankeylake Moor on the southern slope of Llanmadoc Hill. It is said that the Iron Age people of The Bulwark were deadly enemies of the occupants of the Hardings Down hillfort, just to the south. In a deadly battle between the two forts, the slaughter was so fierce that the blood flowed copiously and filled a lake named Tankey or Tonkin Lake after The Bulwark's leader, Tonkin, who was killed in the battle.

Thistleboon

High above the old village of Mumbles, on the south-western flank of Mumbles Hill, lies the community of Thistleboon, a place with a character all of its own. A steep climb up Western Lane, to where it meets Village Lane, leads to the start of Thistleboon Road where the first house on the corner is called Yr Hendy Cwrw ('The Old Beer House'), reminding us of its days as a pub, appropriately called the Hill House. The pub was closed in 1907 after problems with drunkenness, probably caused by the many day trippers visiting Mumbles Hill. The old pub became the village stores for many years and is now a private dwelling house. Carry on up the hill for a short distance and there's a house facing down the lane, where a footpath goes left up onto Mumbles Hill. This was also a pub way back in the 1840s, and was probably an earlier location for the

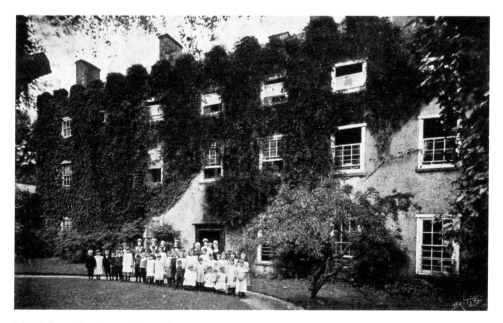

Thistleboon Orphanage in 1908.

Hill House. The remains of the pub's old malthouse may be seen alongside. Another early pub, called the Ship Inn, was recorded in Thistleboon in the eighteenth century.

Mumbles Hill itself is a Local Nature Reserve and offers magnificent views over Swansea Bay and the coast. During the Second World War there were extensive anti-aircraft and defensive gun emplacements on the hill and the remains of these can still be seen, together with display boards explaining their purpose. The Thistleboon Caravan Park lies adjacent to the hill.

At the top of Thistleboon Road, on the corner of the junction with Higher Lane, once stood the Thistleboon Orphanage, occupying an imposing stone-turreted building adjacent to Woollacott's Farm. The orphanage was established in the old building in 1898 and was officially known as St David's Diocesan Home. It provided a safe and secure home for around thirty to forty children and lasted until 1939. The much-loved Miss Rose Scott (fondly known as 'Lady') was a mother to the children there for many years. There are numerous recorded memories of happy times there, including the visits at Christmastime of carol singers and the fabled Horse's Head. The orphanage and farm have long since disappeared, to be replaced by housing.

The blue plaque to Morfydd Owen at Craig-y-Mor, Thistleboon.

Continuing along Plunch Lane, there's a large house named Craig-y-Mor, which was once known as 'The Farm'. The 1844 tithe map shows a 'Brewhouse and Shed' opposite the farm, occupied by John and Thomas Nicholls who were also innkeepers at the Hill House pub lower down the hill. They probably grew barley on the adjacent fields, ready for malting at the malthouse alongside the pub.

There's a blue plaque on the wall at Craig-y-Mor remembering the tragically short life of Morfydd Owen, the brilliant young Welsh composer and mezzo-soprano who sadly died there in 1918, just before her twenty-seventh birthday. Morfydd had recently been married to Dr Ernest Jones of Gowerton, the well-known psychoanalyst and biographer of Sigmund Freud. They were holidaying at Craig-y-Mor when she was suddenly taken ill and died following complications. Morfydd Owen was surely destined to become one of the greats of Welsh music.

Further along the lane there's an exclusive complex developed by the famous Welsh actress Catherine Zeta-Jones, and then we come to the home of Mumbles Cricket Club. The Marespool cricket ground has a spectacular location, perched high on the clifftop, and has been the cricket club's home since the 1970s. The club was established in 1925 and played its games at Underhill Park before the land for the present ground was purchased from the Duke of Beaufort. Much hard work was carried out by club members to develop the new ground and they can justifiably be proud of the facilities there. The club plays in the top tier of the South Wales Premier League and runs a number of Senior and Junior teams. They have an impressive clubhouse, recently extended, that's very popular for functions.

U-boat at Pwlldu

Another Gower story tells of a German U-boat crew coming ashore at Pwlldu Bay during the Second World War to replenish their supply of fresh water. The Bishopston stream flows down the valley into the remote bay and it would have been relatively easy to obtain fresh water from the stream at dead of night when the residents of Pwlldu's two cottages were either not in occupation or fast asleep. Whether the U-boat captain would have been prepared to take the risk of entering enemy territory is another question. I guess it depends on how desperate they were for water.

Certainly, in the early part of the war, German submarines were known to be operating in the Bristol Channel, engaged in intelligence-gathering operations. There is a reported account of a German U-boat being sunk in the channel off Pwlldu Head on Easter Monday in 1940, so perhaps the story is not as far-fetched as it sounds.

Underhill Park

Close to the heart of Mumbles, along the Newton Road, lies the lovely open green space of Underhill Park. With attractive woodland on its fringes and a range of sporting and leisure facilities, it is a much-valued asset for the community. The park has been owned by the City and County of Swansea since 1923 and is popular with families and dog walkers, and includes rugby, football and cricket pitches. It is the home venue of Mumbles Rugby Club (formed in 1887) which runs Senior and Youth teams, as well as eleven Junior teams. The Mumbles Rangers football teams also play at the park and they run boys' and girls' teams from Under-6 to Under-16 and Youth, Seniors and Ladies teams. In the summer, Swansea Cricket Club plays matches at the park. It has been estimated that around fifty sports teams regularly play there. The park also has an excellent children's play area that was recently refurbished with modern play equipment, a much-needed upgrade that was completed largely thanks to the efforts of the Friends of Mumbles Parks.

Some of the facilities at the park, including the existing changing rooms and public toilets, are in a poor state and need to be replaced. To this end an ambitious project

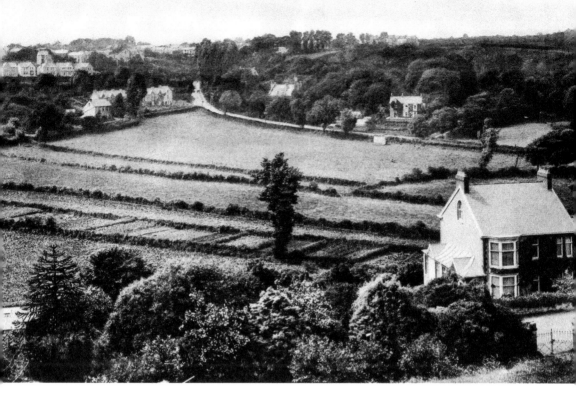

Above: Early picture of 'Langland Vale' when Underhill Park was just fields.

Below: A view of Underhill Park with the existing changing rooms in the foreground.

has been set up locally, called 'Go Underhill', with the aim of transforming the park in several stages. A registered charity has been formed to take the project forward and includes all the interested parties together with support from Mumbles Community Council. The charity has negotiated an agreement to lease Underhill Park from Swansea Council, and to manage it on a long-term basis.

In 2019, planning permission was granted for Phase One of the project. This phase includes the upgrading of the dilapidated pavilion and the provision of new public toilets and a meeting room, replacement of the changing rooms with brand new facilities, plus the addition of a multipurpose community hub and café, a toddlers' play area and improved landscaping. The plans also include a new floodlit all-weather pitch to generate income and ensure sustainability of the park. The cost of delivering the first phase is estimated to be around £2.4 million and, as of June 2021, grants have been secured for up to £1.9 million of the cost from The National Lottery Community Fund, Mumbles Community Council, and from Welsh government's Community Facilities Programme. This will enable the core building work to commence, while the balance funding needed to enable the all-weather pitch to be built is still being sought, through further grant applications, donations and sponsorship. The proposals will ultimately offer improved facilities for the whole community of Mumbles and enhance this splendid environment for the modern day and for the future.

Artist's impression of proposals at Underhill Park. (Courtesy of MCA)

V

Verry Volk

And now for some Gower fairy stories, various versions of which have been handed down over the years. The Gower fairies have always been known as the 'Verry Volk' rather than the 'Tylwyth Teg' referred to in other parts of Wales. The name probably comes from 'fairy folk' spoken in the Gower dialect. The little fairies were said to always dress in scarlet and green and dance in the moonlight. One story relates to Pennard Castle and the wedding feast of the warrior chief who lived there. During the drunken revelry one of the guards could hear music coming from the castle yard and, on investigation, he discovered the Verry Volk dancing there to the accompaniment of their tiny harps. When he reported this, his master was enraged as he didn't want any fairies in his castle. He rushed to the castle yard, brandishing his sword and frightened the fairies away. It was very risky to offend the Verry Volk and so, on the same night, a terrible storm blew up causing the castle walls to come crashing down. The castle became covered in sand and has been in ruins ever since.

The Verry Volk were very active in the Llanmadoc area and another story concerns the farm at Lagradanta. A strange old woman arrived at the farm one day and asked if she could borrow a sieve. The farmer's wife said she didn't have a sieve, whereupon the old woman reminded her that she was using one in the kitchen to strain hops for the making of beer. At this point the farmer's wife suspected the old woman was really one of the Verry Volk as they were reputed to use sieves for the sifting of gold. She cleaned the sieve and handed it over and when the old woman returned it several days later she thanked the farmer's wife, saying that as a reward the beer in the farm's largest cask would never run out, just as long as the farmer's wife kept the secret. The farmworkers and the locals enjoyed limitless beer for many weeks until the day the farmer's wife gave away the secret while gossiping and the cask immediately ran dry. Similarly, a maid at the same farm found a shiny new penny there every day until she mentioned it to somebody else and then the pennies suddenly stopped appearing.

There's a little flat green at the nearby hamlet of Cwm Ivy, where the Verry Volk used to dance in the moonlight. A local man inadvertently entered their circle without permission and, as punishment, his foot was pierced with a pitchfork. After limping

away, he was advised by an old woman to return and apologise, which he did, and his foot was miraculously healed. If you wish to observe the Verry Volk, it is best to first make yourself invisible, by turning your jacket inside out.

The Vile

The Vile is an ancient field system at the south-western tip of the Gower Peninsula, situated on the flat headland between the village of Rhossili and the cliffs. This open field system of strip farming has existed here since at least medieval times, and may even predate the Normans. It is one of the very few locations in Britain still set out as it was centuries ago and continues to be farmed today using the old methods. It consists of a system of narrow strips of land separated by grass-covered earth or drystone banks known as 'landshares'. The banks also act as raised paths and provide shelter and protection for the crops in the field strips. The name 'Vile' is derived from the word 'field', possibly from the old Gower dialect.

Aerial view of The Vile at Rhossili. (Courtesy of Coflein)

The open field system was a method by which villagers could share the land by renting strips from the local landowner. Some tenants would rent several strips, resulting in plots of varying sizes known as 'bundles'. The strips were sometimes scattered and managed so that different tenants could have access to the best ground at different times. A record dated 1731 describes the land as the 'Great Field' or 'Rhosili Field' and outlines the tenancies and the periods of allowed access. Communal grazing was allowed at certain times on fallow fields and on fields in stubble after crops were harvested. Some strips were retained by families through the generations and were even combined through marriage. This has helped to preserve them through the centuries.

There were once other strip field systems in Gower and elsewhere, but the Vile is by far the best example of open field cultivation in Wales. Much of it is now owned by the National Trust, who rent out some of the strips to local farmers. The Trust also farms the land in the ancient style, and its rangers and volunteers have planted crops like oats and barley and flowers such as poppies, lupins and lavender. The planting of sunflowers, however, has been the most spectacular success. Many visitors come to this lovely spot to see the beautiful sunflowers on the headland overlooking the Worms Head. The Trust has also been actively restoring some of the landshare banks that were removed in the past when farming trends were towards larger parcels. The banks play an important part in protecting and preserving the wildlife of the Vile and careful land management has helped to attract many species of birds, butterflies and insects.

Sunflowers at The Vile. (Courtesy of Colin Griffiths)

Whiteford

The Whiteford Burrows promontory extends northwards for over 2 miles into the Burry Estuary from the north Gower coast near Llanmadoc. Whiteford (pronounced 'Witford') is National Trust owned and includes one of the richest dune systems in Britain as well as a conifer plantation. It is also a National Nature Reserve with excellent flora habitats that support around 250 different flowering plants, including varieties such as marsh orchid and dune gentian. On the west side, backed by the dunes, lies the 2-mile expanse of Whiteford Sands, a lovely stretch of tidal beach that is rarely crowded due to its relative inaccessibility. On the east side are the wide salt marshes of Landimore and Llanrhidian. There are many bird species to be seen here, including oystercatcher, golden plover, curlew, little egret and redshank and there's a hide in the Burrows for birdwatchers. Access to the area can be gained by using footpaths from Cwm Ivy (there's a car park with an honesty box between Llanmadoc Church and Cwm Ivy). Near to the car park, at the south of the Burrows, is Cwm Ivy Marsh, a new salt marsh now flourishing with wildlife after being successfully restored from its previous freshwater state following the breach of the adjacent sea wall in 2014.

To the north, just off Whiteford Point, is the iconic cast-iron lighthouse, which can be accessed (with caution) at low tide. It's further than it looks, and the tides here can be very dangerous. The lighthouse is surrounded by the sea as the tide comes in and it is the only wave-swept cast-iron lighthouse of its size left in Britain. The lighthouse was built in 1865, replacing an earlier wooden structure, and warned ships of the shallow waters around Whiteford Point. The light was decommissioned around 1920 after the beacon was established on Burry Holms but was relit for a period in the 1980s at the behest of local yachtsmen. Whiteford Lighthouse is Grade II* listed and is a Scheduled Ancient Monument.

There was a terrible shipping disaster at Whiteford on 22 January 1868 when a fleet of sailing vessels was subjected to enormous seas in the estuary, resulting in much wreckage and loss of life. For several days previously, the nineteen vessels, some carrying up to 400 tons of coal, had been moored in the Port of Llanelly while sheltering from westerly gales. By the afternoon in question, the storms

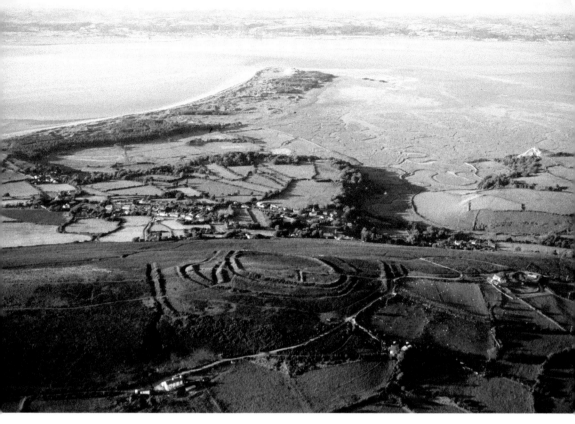

Above: The Whiteford promontory looking north, with Llanmadoc Hill and The Bulwark in the foreground. (Courtesy of Coflein)

Below: Whiteford Lighthouse. (Courtesy of Thomas Guest under Creative Commons 3.0)

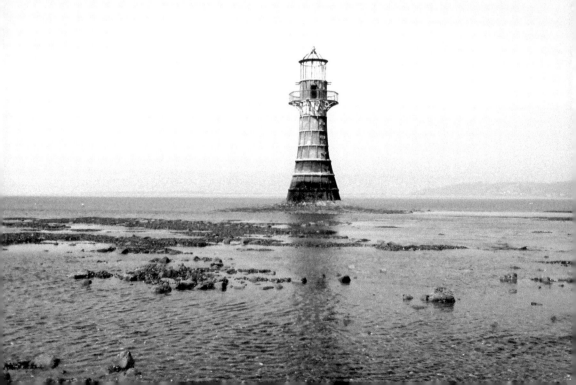

had abated and, in light wind, the fleet proceeded down the estuary, some under tow from steam tugs, aiming to reach a position from where they could safely use their sails. The sand bar in the approaches was a clearly known danger but, unknown to the ships' masters, there was a tremendous groundswell on the bar that was travelling up the estuary. With little wind to catch the sails, and despite using anchors, the vessels began to drift dangerously. Some were wrecked on the bar and were broken up, some collided with each other, and others were driven on to the beaches and the rocks. Some crewmen managed to survive by clinging onto the hulk lightship in Broughton Bay, but others were not so lucky. At daybreak the next morning the full scale of the tragedy could be seen all along the sands of Whiteford and Broughton Bay where the wreckage of ships, cargo and human bodies were strewn. Around a dozen of the original nineteen ships were wrecked and it was originally thought that over fifty crewmen had lost their lives, but the final death toll stood at eighteen. The inquests of some of the victims were held at the Farmers Arms in Llanmadoc, where the verdicts were given as 'found drowned'.

Worms Head

Worms Head is a place of legend that rises like a great serpent from the sea at the most westerly tip of Gower. It's a spectacular, mile-long, narrow tidal island, joined at low tide to the promontory on the west of Rhossili village. Its name comes from the old English (possibly Viking) word 'wurm', meaning 'serpent' or 'dragon', which describes it very well. Access is possible across the causeway for around 2½ hours either side of low tide, when a scramble across the jagged and slippery rocks leads to the flat-topped Inner Head whose grassy summit rises to around 150 feet. Another rocky belt then leads to the Low Neck, connected to the Middle Head by the Devil's Bridge, which crosses a natural limestone arch on a narrow strip of rock. More rocks lead to the highest and most distant section: the Outer Head, which forms the head of the 'worm'. This is the home of the Worms Head Cave, sited on its westerly tip, and there's a natural blowhole on the north side that in certain conditions produces loud rushing and booming sounds. Breeding seabirds here include herring gulls, guillemots, razorbills and kittiwakes. Access to the Outer Head should be avoided between 1 March and 31 August to avoid disturbing the nesting birds. Sheep have been grazed on Worms Head in the past and they were apparently very reluctant to leave their island home when they came to be moved back to the mainland.

Worms Head has been much written about, notably by Dylan Thomas, who tells a story about being trapped there by the tide together with his friend, Ray. The short story entitled 'Who Do You Wish Was With Us?' features in his book *Portrait of the Artist as a Young Dog*, a classic collection of reminiscences of the young Dylan. In his

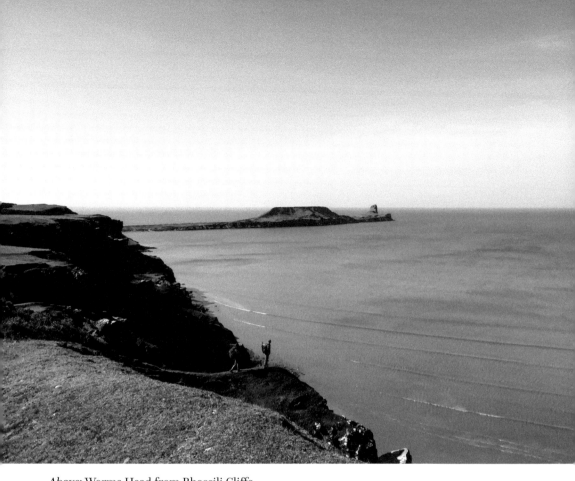

Above: Worms Head from Rhossili Cliffs.

Below: Worms Head causeway with a warning notice about the tides.

inimitable style he writes, 'Even on this calmest day a wind blew along the Worm. At the end of the humped and serpentine body, more gulls than I had ever seen before cried over their new dead and the droppings of ages.' He said to his friend, 'Why don't we live here always? Always and always. Build a bloody house and live like bloody kings!' and then he said, 'This isn't like any other place.' There's nothing more I can add.

X

Mr X

One of Mumbles's best-known characters in the post-war years was Reg Cottle, a local builder and father of Geoff, Tony and Kim. So often did Reg's name appear in the *Mumbles News* of the time, that complaints were received about his continual appearances! Thereafter he was always referred to in print as 'Mr X' and his appearances continued as such, although everybody knew who he was.

The Cottles are a very old Mumbles family, going back for generations in the village. Reg's father, Richard, was a stonemason and his grandfather, Charles Cottle, was an oyster dredgerman. His uncle, another Charles Cottle, was the last lighthouse keeper of Mumbles lighthouse before it was automated. Reg's grandfather on his mother's side, William Jenkins, was also an oyster dredgerman and was a member of the Mumbles lifeboat crew. William and his brother John sadly lost their lives in the lifeboat disaster of 1883, when four of the lifeboat crew perished during the brave rescue attempt of the sailing barque *Admiral Prinz Adelbert*, which was wrecked on the rocks of Mumbles Head.

Mr X was a good friend of 'Captain Jack' Williams and they shared many escapades together. They also carried out good works, including the raising of funds for the dependants of the lifeboatmen who lost their lives in the Longhope (Orkney) lifeboat disaster in 1969. Together they made collections around the pubs and clubs of Mumbles, as well as organising a dance at the Pier Hotel. They raised a total of £260 10s – a considerable sum at that time. Reg was also well known for his sporting prowess. He was a very good hockey player and skilled at table tennis as well as being a keen golfer and member of Langland Bay Golf Club. He was also a member of the championship-winning Beaufort Arms darts team of 1954.

He was sometimes to be found at the Park Inn, in Park Street, and the 1960s photograph overleaf shows mine hosts Winnie and Ronnie Jenkins, showing one of Winn's works of art to the regulars. Reg Cottle (Mr X) is on the right, next to 'Captain Jack' Williams. The one at the rear of the picture holding the pipe is Bill Morris, standing next to his next-door neighbour Sam Davies (the one with the cap). In the picture of the hockey team, Reg is the one in white, although the original caption asks: 'Why was he there? Lord knows, but he gets in everywhere doesn't he?'

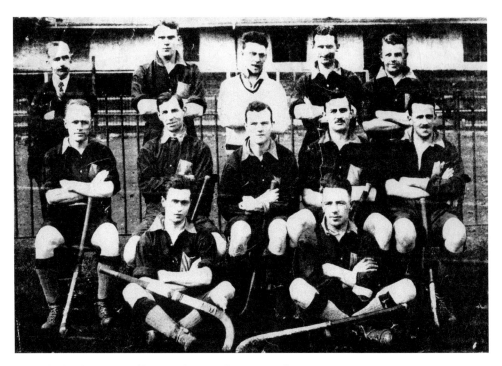

Mumbles hockey team of bygone days, with Mr X in white.

The Park Inn, Mumbles, *c.* 1960, with Mr X on the right.

One of many stories relates to half a dozen members of the golf club going up to Scotland for the rugby international, travelling by car. They stopped halfway at a pub for a break and while they were having drinks they watched the landlord attempting to plaster the chimney breast in the bar. He wasn't having much success, so Reg (a plasterer by trade) offered to help. He ended up plastering the whole chimney breast himself. When asked what payment was required, Reg suggested having lunch and they were promptly served with six lunches, all free of charge. While in Scotland the group also enjoyed a round of golf at St Andrews (also organised by Reg), so all in all it was a very successful trip.

Reginald Cottle sadly passed away in December 1979, aged sixty-nine, but the memories of Mr X will live on.

Yachting in Mumbles

Yachting is very popular in Swansea Bay and has a long history. Racing was taking place in the early 1800s when pilot boats and local oyster skiffs competed against each other. At that time Swansea was developing as a major port with the growth of the coal, copper and shipbuilding industries and there were a number of influential and wealthy families in the town who were keen to promote yacht racing in Swansea Bay. In the 1820s and 1830s, important regattas were held, and yachts came from other ports to compete for the challenge cups and trophies. During the nineteenth century over 200 large yachts raced in Swansea Bay.

Mumbles is fortunate to be the home of two prestigious yacht clubs. The earlier of these is the Bristol Channel Yacht Club (BCYC), which was formed in 1875 and was the first yacht club established in the Bristol Channel. The BCYC held its early meetings in the George Hotel and held a major regatta in its first year. The club soon had 130 members and its first commodore was Henry Hussey Vivian of Singleton (later Lord Swansea). The membership included many prominent local businessmen and industrialists, many of whom who were also yacht owners. In 1883, the BCYC moved its headquarters to the Treffgarne private hotel in Mumbles Road and in 1896 organised the famous Royal Regatta in which a number of great yachts competed, including the Royal Yacht *Britannia* and the Emperor of Germany's yacht *Meteor*. The regatta's gold cup was won by the yacht *Ailsa*, owned by A. B. Walker Esq. *Britannia* came second, although *Meteor* unfortunately lost its mast during the race and withdrew. Thousands of people thronged the shoreline to witness this historic event.

In 1902, the BCYC acquired land adjacent to Libby's Forge and built their splendid new clubhouse, which was opened by the Earl of Jersey in 1904. The membership continued to grow and the club organised a number of large regattas in the following years that again attracted vast crowds. As well as the yachting, members were able to enjoy the club's excellent dining facilities and to play billiards and snooker. This continues today and the club is also the meeting place of a number of local organisations, including the Probus Club of Mumbles.

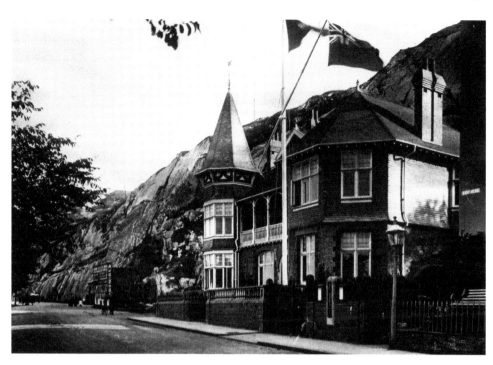

Above: The Bristol Channel Yacht Club in 1907.

Below: The Mumbles Yacht Club clubhouse in 2011. (Courtesy of Joe Crawford, MYC)

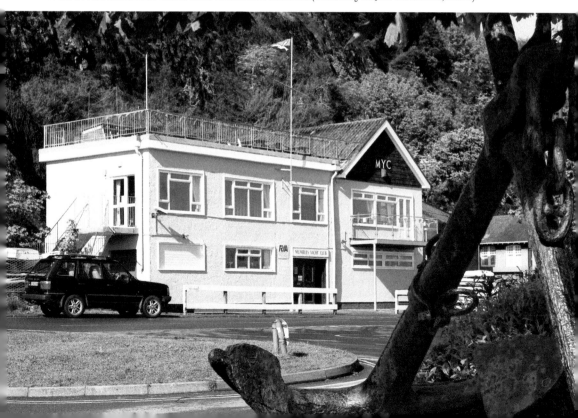

Since the Second World War the club has enjoyed a close association with the neighbouring Mumbles Yacht Club and supports numerous major yachting championships.

The Mumbles Yacht Club was formed in 1938 by local enthusiasts and its first headquarters was at the Pilot Inn, a popular 'after sailing' venue for yachtsmen. The club organised a full racing season during its first year but ceased to operate during the Second World War, reactivating in 1946. Their races were run from the shore and the club had a small white tin hut on the promenade that acted as the race office. A wide range of craft took part in the races and a strong local fleet also competed farther afield.

The club later moved to its Yacht Room at the Mermaid Hotel, but a rapid increase in its membership and activities raised the need for a proper clubhouse. A piece of land became available where the club stands today and the members contributed in many ways to build the new clubhouse, including generous loans, donations and much free labour. The opening ceremony took place in 1959 and the premises was later extended as sailing activities increased. The membership rose to over 900 and many designs of boats were able to take part in competitive racing. The Mumbles Yacht Club soon became a popular venue for World and National Championships and weekend regattas. In 1983, the club hosted the *Mirror* dinghy world championships

The 'Dart' European Championships of 2014 hosted by Mumbles Yacht Club. (Courtesy of Simon Edwards, MYC)

when the young Ben Ainslie competed and won. He later famously went on to win several Olympic gold medals.

Mumbles Yacht Club currently operates a twelve-months-a-year sailing programme for dinghies and catamarans and is also a recognised Royal Yachting Association training establishment. In addition, it continues to host international and national championship events. The last major event was the Dart 18 European Championships in 2014, although there have been several smaller national events since then.

Action in Swansea Bay from the 'Osprey' National Championships of 2016. (Courtesy of Simon Edwards, MYC)

Zoar Chapel, Crofty

Crofty was once a little hamlet centred around Crofty Farm, which dated back to the eighteenth century. It was here that farmer William Thomas was granted a licence for the 'Crofte Inn' in 1858 and he was able to provide refreshment for visiting seamen who were shipping coal to the area at that time. As the surrounding locality developed its own thriving coal industry, the village of Crofty expanded to house the colliers and their families.

Zoar Chapel in Crofty. (Courtesy of Phil Davies)

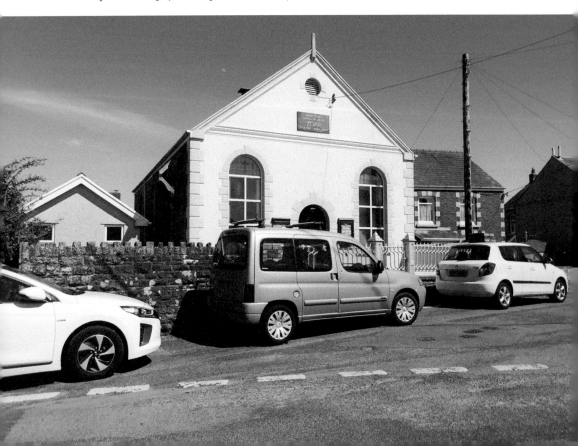

Religious meetings were held in people's homes before a Sunday school was eventually established in Crofty. This led to the building of Zoar Chapel in 1884 and the chapel was initially a branch of Tabernacle Presbyterian Chapel in Penclawdd. Its name derives from the Book of Genesis, where Zoar is the name of the place to which Lot fled from the destruction of Sodom and Gomorrah. Zoar was one of five ancient cities in the Jordan valley and the name in Hebrew means 'small'.

The religious revivals of 1904/5, in which Evan Roberts of nearby Loughor was a prominent leader, had a tremendous effect across South Wales, and in 1906 Zoar Chapel was rebuilt and extended. The minister at the time was Revd D. M. Davies, who served at Crofty and at Tabernacle Penclawdd between 1888 and 1911. Zoar became a separate church in 1908 and subsequently called its own pastor. It proudly celebrated its centenary in 1984 and continues to play an important part in the spiritual life of the community.

The Crofty of today is a pleasant residential village alongside the estuary, nowadays known for its association with the local cockle industry, and where both inn and chapel are long established.

Acknowledgements

I would like to thank the many people and organisations who have contributed photographs and information to help me prepare this book. These include Dr Ronald Austin (archivist of Bristol Channel Yacht Club), Esme Allchurch, Peter Bray, the Clare family, Geoff and Tony Cottle, Alistair Dixon (Sweyn's Ey), Dave Dow (archivist of Swansea RFC), Colin Griffiths, Keir Jones (Zoar Chapel), Dick Lewis (commodore of Mumbles Yacht Club), Carolyn Llewellyn, Rob Marshall, Bernard Mitchell, Dave Morgan, Fiona Rees, Cathy Roberts and Marc Smith Photography. Organisations include the Canterbury Museum in New Zealand, Dunvant Male Choir, 'Go Underhill', Mumbles Development Trust, National Library of Scotland, Oxford University Museum of Natural History, Oystermouth Historical Association, the Royal Commission on the Ancient and Historical Monuments of Wales and the Scott Polar Research Institute in Cambridge.

The old photographs have been collected from a wide range of sources. Some of the older material is out of copyright, and for the remainder every reasonable effort has been made to trace the copyright holders for permission to reproduce. In some cases, this has not been possible, and I apologise for any unintentional infringement which will be corrected at the earliest opportunity. The present-day photographs are my own work, apart from those that are separately acknowledged, including those by my son, Phil, who deserves a special mention for his photographic skills.

There have been many excellent books and publications produced about Mumbles and Gower and authors referred to include Rod Cooper, Paul Ferris, Gary Gregor, David Gwynn and Peter Muxworthy, Joan N. Harding, Dorothy Helme, Heather Holt, Neville Jones, Robert Lucas, Howard Middleton-Jones, David Rees, P. E. Rees, Carl Smith, J. Mansel Thomas, Wynford Vaughan Thomas, Horatio Tucker and Pat Williams.

The internet is an increasingly valuable source of information and the many websites visited include 'coflein', 'exploregower', 'gowershipwrecks', 'historyofmumbles', 'thisisgower' and numerous media websites.

I would finally like to acknowledge the vital role the National Trust plays in protecting much of the special landscape of Gower. The Gower Society has also done great work over many years and their *Gower Journal* and other publications have been the source of much invaluable information, and I would like to offer a collective thank you to their many contributors.

About the Author

Brian retired from the electricity supply industry a number of years ago, after a career as an engineer and manager, having worked throughout South Wales. Originally from the Eastern Valley of Gwent, he moved to Mumbles some thirty-eight years ago. He was educated at West Mon Grammar School in Pontypool and completed his professional qualifications at the University of Wales, Institute of Science and Technology in Cardiff. He's also a keen singer and has sung in choirs all around the world, having toured many times overseas with the Cwmbran, Morriston Orpheus and Phoenix Choirs. He currently sings with Mumbles A Cappella.

His interest in local history saw him publish his first successful book about Mumbles and Gower pubs in 2006, a subject he revisited in a new book in 2018. He has always been a keen walker and has ascended most of the main peaks in Wales and completed numerous long-distance trails. His idea of walking from the southernmost to the northernmost point in Wales saw the publication of *Wales: A Walk Through Time*, an illustrated account of his journey in three volumes. Another recent book, *Mumbles and Gower Through Time*, explores the way a delightful corner of Wales has changed over the last century. Brian enjoys giving talks about his books to many different organisations.

Brian is a past president of the Probus Club of Mumbles and is currently chairman of Oystermouth Historical Association. He and his wife Mari have a son and daughter and five very special grandchildren.